ROBIN HOOD'S BAY & FYLINGTHORPE
THROUGH TIME
Robin Lidster

AMBERLEY PUBLISHING

In memory of
John Ronald Lidster
1916-2008
who enjoyed the beauty and the magic of
Robin Hood's Bay

Front Cover photographs:

Beacholme, Robin Hood's Bay
Once a fishing village where the hardy fishermen served as volunteers in the rowing lifeboat, and smugglers plied their illegal but highly lucrative trade, the village is now the haunt of holidaymakers and visitors, who appreciate the magic and the beauty of this North Yorkshire village.

First published 2009

Amberley Publishing Plc
Cirencester Road, Chalford,
Stroud, Gloucestershire, GL6 8PE

www.amberley-books.com

Copyright © Robin Lidster, 2009

The right of Robin Lidster to be identified as the
Author of this work has been asserted in accordance
with the Copyrights, Designs and Patents Act 1988.

ISBN 978 1 84868 663 2

British Library Cataloguing in Publication Data.
A catalogue record for this book is available from
the British Library.

Typeset in 9.5pt on 12pt Celeste.
Typesetting by Amberley Publishing.
Printed in the UK.

Introduction

Robin Hood's Bay and Fylingthorpe are the two main villages in the parish of Fylingdales situated 4 miles south of Whitby on the North Yorkshire coast. The name of Robin Hood's Bay can be traced back to the time of King Henry VIII in 1538. Prior to this, the area was known as North Fyling and South Fyling, which were mentioned in the Doomsday Book.

The chief industries here were farming and fishing, and in 1816, Robin Hood's Bay had about forty fishing boats and around 130 full-time fishermen. Additional income from smuggling was not inconsiderable as it was a very lucrative trade, which involved many people from every strata of the community. The higgledy-piggledy nature of the village, with its narrow cobbled alleyways, secret tunnels and escape routes, was ideal territory for the smuggler.

The question often asked by visitors is 'what is the connection with Robin Hood?' There are many theories but most are based on folklore and legend, indeed there is even dispute about the identity of Robin Hood. Locally, it was believed that he kept a couple of boats here so he could escape across the North Sea for temporary refuge. Other stories relate to features of the landscape — some burial mounds on the moors above the bay were called Robin Hood's Butts and are supposed to be where he and his men honed their archery skills. Whatever the facts, there is no doubt that his connection with the village, however tenuous, has helped to spread its fame far and wide.

The greatest change in Robin Hood's Bay came about in 1780 when there was a massive cliff fall and twenty-two cottages fell into the sea, along with a section of the only road. This then entailed the building of a completely new access road into the village that comprises Bay Bank and New Road leading down to The Dock. Traces of the old road can be seen at the top of Bay Bank, near the Victoria Hotel, and in King Street, down in the old village.

Tourism started back in the eighteenth century when visitors were warned that the road from Scarborough to Robin Hood's Bay was 'stony and uneven over a dreary barren moor'. It was not until the Scarborough and Whitby Railway was opened in 1885 that visitors and holidaymakers started to arrive in any quantity. Over the eighty years that the line was open, hundreds of thousands of visitors came to the 'Bay', as it was popularly called. Sadly, the line closed in 1965 with the increasing use of the private motorcar.

The two villages of Robin Hood's Bay and Fylingthorpe have changed considerably over the years, although it has been, mostly, a gradual change, which largely goes unnoticed until 'then and now' photographs are compared. It has been my intention to present the photographs in this book so that the reader can see not only the physical changes in the villages but also aspects of the social life and activities of both residents and visitors.

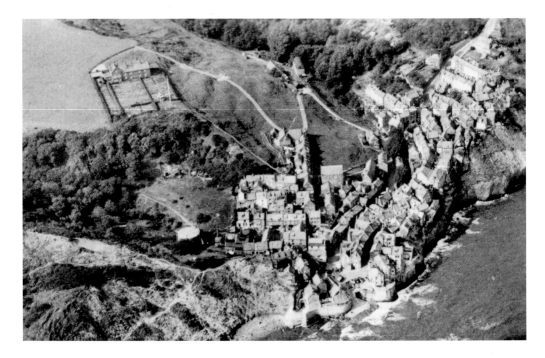

Aerial View of Robin Hood's Bay
Most of the old village can be seen on this aerial photograph taken in about 1930. At the top right, the steep Bay Bank commences its descent into the village and its course can be traced down to the slipway onto the beach at Wayfoot. Towards the top left, the new Coastguard Station and its houses are perched in a field overlooking the village. Below the coastguard station is the village gasworks that operated between about 1861 and 1961.

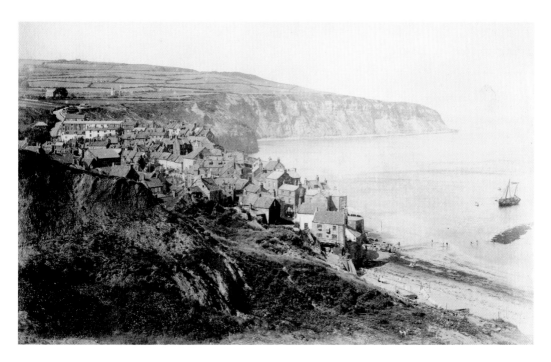

The Old Village

Robin Hood's Bay from the south: the tightly packed houses of the old village cling precariously to the sea cliff and the sides of a narrow ravine. The greatest changes, in recent years, have been the sea walls and rock armour that now protect the village. The pantiled roofs of the old village, often called Bay Town in Victorian times, glow in the morning sunshine. The headland at the north side is known as Ness Point or North Cheek.

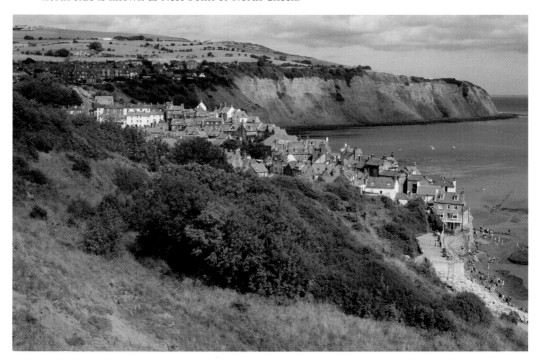

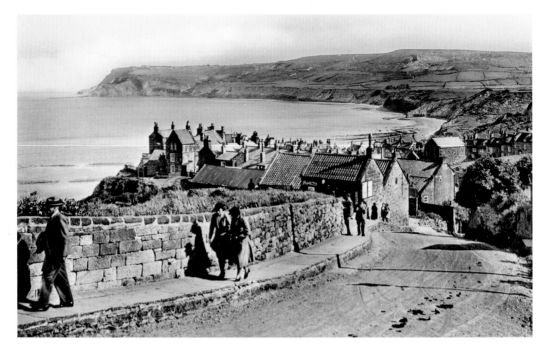

Bay Bank Top

A magnificent view over the old village and bay to the lofty cliffs of Ravenscar. This is the only road in and out of the village, and prior to the arrival of motor vehicles, everything had to be hauled up or down by horse and cart — from furniture and building materials to coal and coffins! The position of the new lamppost has not enhanced the view and cars, not carts, are now a hazard on Bay Bank.

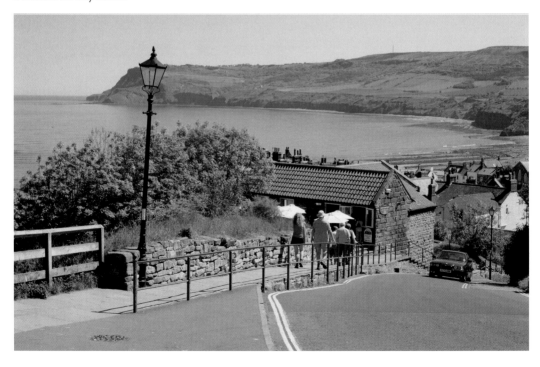

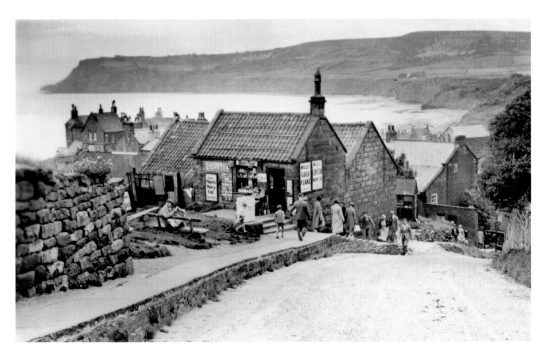

Time for Refreshment

The little tearoom near the top of Bay Bank has always provided visitors and holidaymakers, not used to the steep climb, a welcome refreshment break. It also provided an opportunity to purchase a few picture postcards of this picturesque village. The enamel advertising signs seem to place a heavy emphasis on tobacco products. In recent years, as Candys, it has doubled in size and continues to refresh the visitors. The enamel signs, however, have long since disappeared.

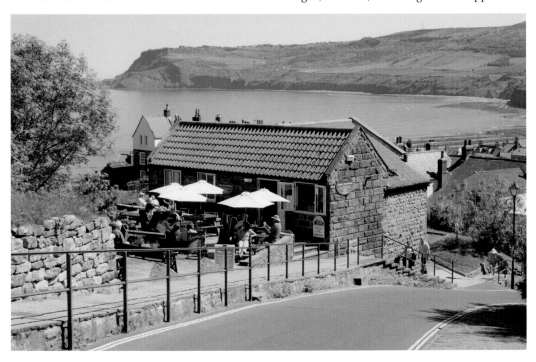

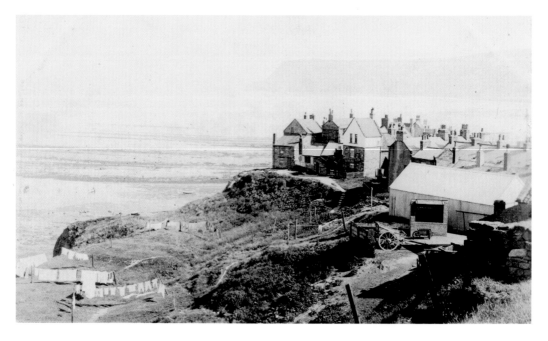

Changing Times

Over a period of two centuries, up to about 1950, the village lost an average of one cottage per year. The large shed on the right was once a cart house with adjacent stables where the heavily-worked horses were kept that carted coal up and down Bay Bank. The under-cliff was once used as a drying ground, but a new road has recently been built, giving access to the shore on the north side of the village for boats as well as people.

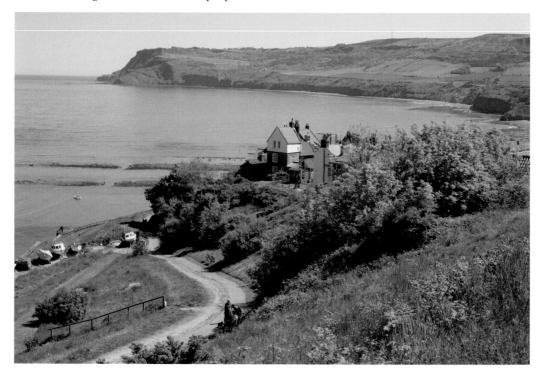

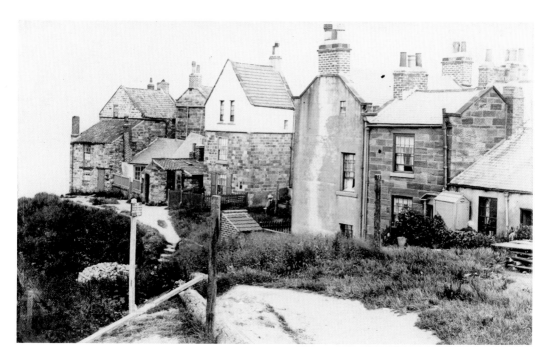

The Vanishing Village

Houses and cottages at the end of the Esplanade. 'Windyridge' is the cottage in the centre with its later third storey painted white. All the houses and cottages on the seaward side of 'Windyridge' succumbed to cliff erosion and only the small outhouse remains. Maintenance of the cottages is a never-ending task. When structural renovations are undertaken, it is often found that the roof and floor timbers of the cottages have been made from the spars and masts of boats and ships.

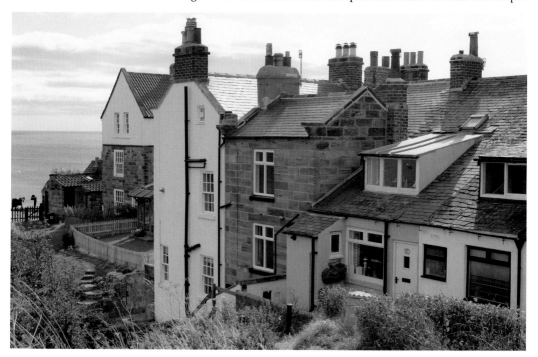

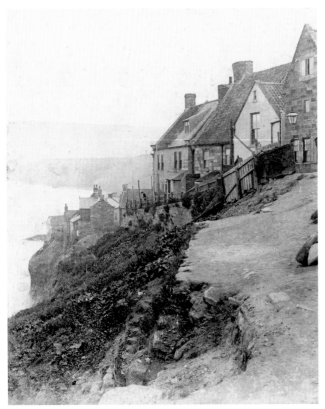

On The Brink

Part of the original road into the village can be seen on this photograph of about 1890. In 1780, there was a massive cliff fall, when a large section of the main road into the village collapsed together with twenty-two cottages. By the late 1940s, some, on the cliff edge, were for sale for as little as £5. Whilst many cottages still appear to be precariously perched, they are now protected by the massive sea wall that was completed in 1974.

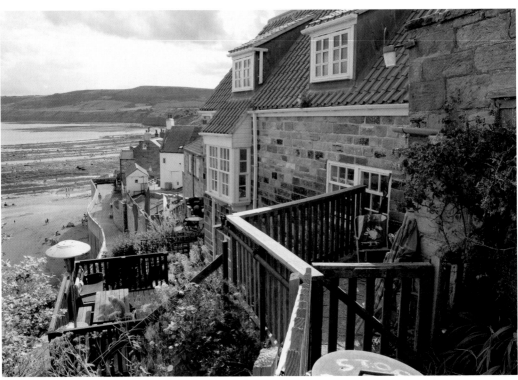

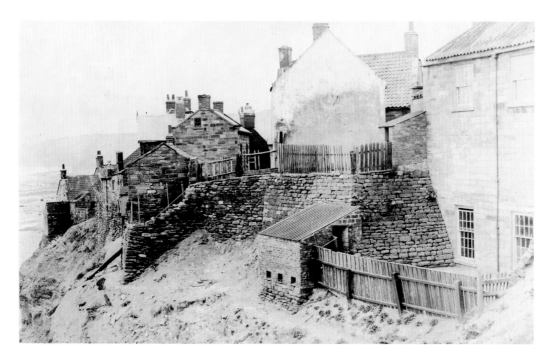

A New Convenience

The dilapidated state of some of the cliff-top cottages can be seen in this photograph of about 1900. On the right is the back of the old Methodist chapel that was completed in 1779. When part of King Street collapsed the following year, they suddenly had a view of the sea! The lower windows were part of the boys' school at the back of the chapel and the fence enclosed a miniscule playground, the small hut providing their toilet facility with its rather primitive drainage arrangements!

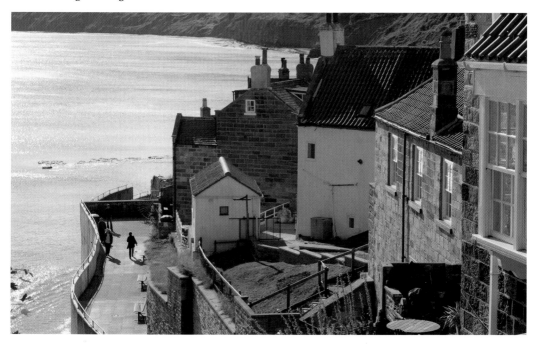

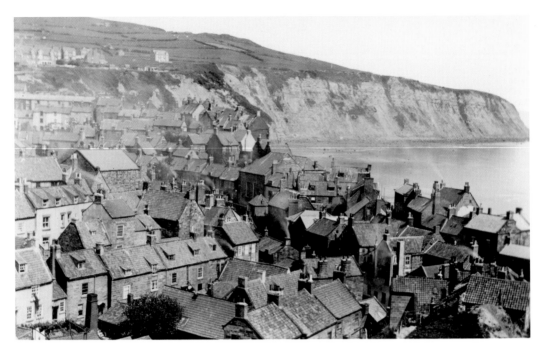

An Economy of Space

A delightful description of the village is given in *Theakston's Guide to Scarborough* of 1847:

> No place of human abode can be conceived more wild in its appearance than this village where the tidy little edifices of the fishermen are perched like the nests of seagulls among the cliffs. Every individual dwelling is characteristic of the neatness of a seafaring proprietor — him whom early habit has taught the true principles of the economy of space and to whom the contrast of rough and perilous hours abroad the more endears the delights of home.

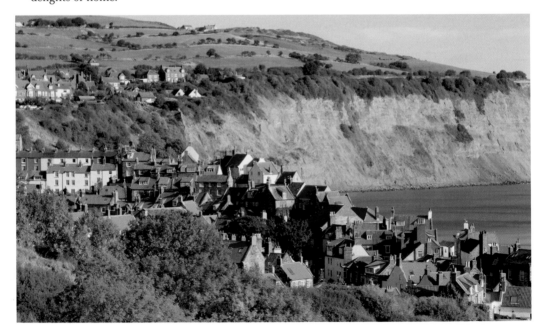

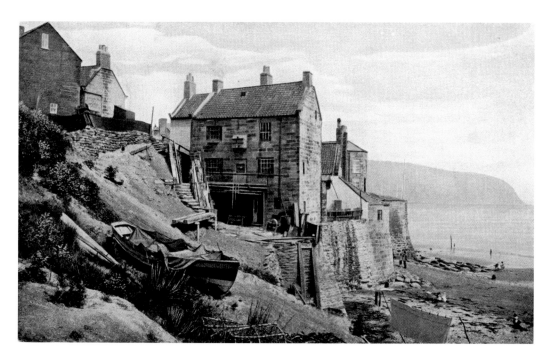

Beacholme

This cottage, with sawmill in the old coloured photograph, was conveniently located near the beach where the sea provided an endless source of wood, often from the wrecks of ships along the coast. It was converted into a holiday cottage in 1897 by the addition of a basement kitchen and two dormer bedrooms in the roof space. The land in the foreground was once large enough to graze cows, but erosion necessitated the building of the Quarterdeck, a short sea wall, in the 1960s.

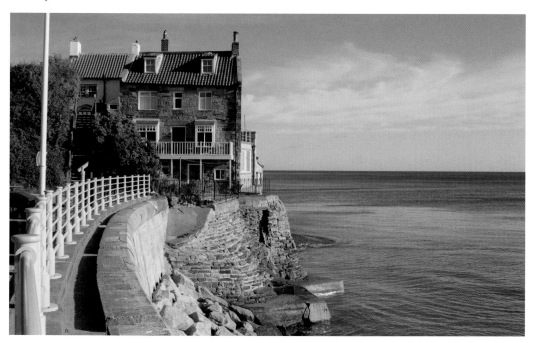

13

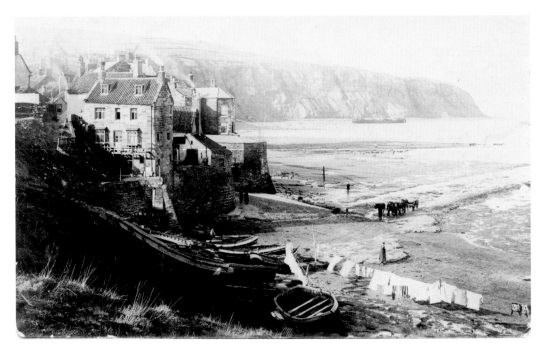

High and Dry

Prior to the advent of tumble driers, the weekly wash was hung out to dry on clotheslines on land round the village and on the beach. A schoolboy, on seeing this photograph and being asked why he thought the residents of the village hung their washing out on the beach in Victorian times, said, 'so that when the tide came in it would wash the clothes'! The Quarterdeck, the short promenade, has recently been extended and augmented with rock armour.

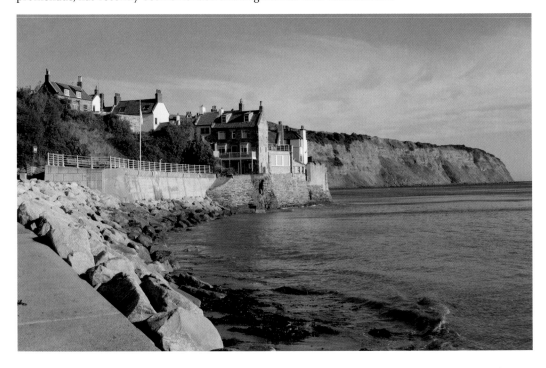

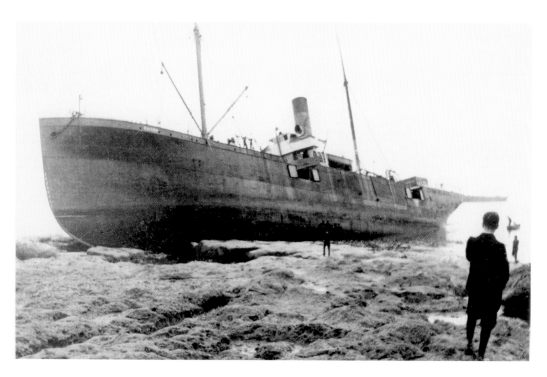

Monsters on the Beach!

The *Kaiser* became stranded in July 1904. It was carrying a mixed cargo of ironmongery, fruit and vegetables, thirteen passengers and a stewardess. Everyone was rescued safely, and for a few days, a boat ferried salved cargo to Whitby. When the boat broke up, the fruit, including strawberries, was washed ashore where local people gathered it up, and for the next few days, the whole village smelt of strawberry jam! Other monsters can be seen when sand sculptures appear on the beach!

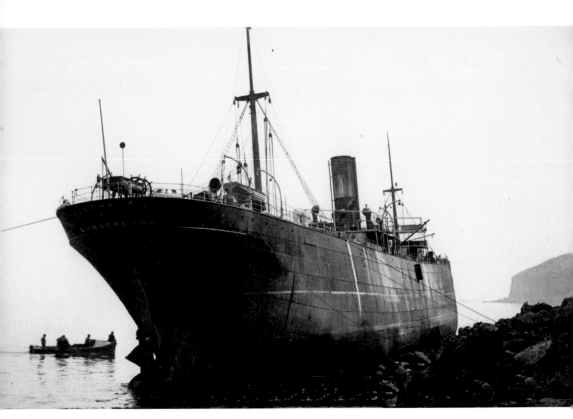

Disasters on Land and Sea

The *Coronation* ran aground at Ravenscar, at the south end of Robin Hood's Bay, on Sunday 11 January 1913. A severe south-easterly gale was blowing and the vessel became unmanageable and stranded at 3.25 a.m. in a blinding snowstorm. When daylight dawned, the crew found they were close to the shore and were able to rig up their own breeches buoy and line to reach dry land. It remained on the shore for several months before being refloated but, by a strange twist of fate, the boat burned out in dry dock whilst it was under repair, owing to the carelessness of a welder. Disasters happen on land too, and the Old Forge Cottage, near the Laurel Inn, was virtually demolished by a runaway digger that hurtled down Bay Bank!

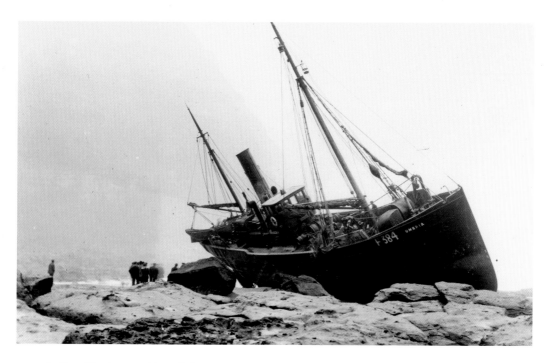

Action Stations at Ness Point

Two photographs a century, and a world, apart. The rocks on this coast have been responsible for the demise of many boats and ships, and some trawler captains believed that the high iron content of the rocks at Ravenscar affected the ships compasses and resulted in a number of strandings. One of these was the Hull steam trawler *Umbria* that ran aground in thick fog in 1898. The crew of eight were rescued by the first Robin Hood's Bay RNLI lifeboat, the *Ephraim & Hannah Fox*. Within ten years, another six trawlers foundered in this location, and it was claimed at a Board of Trade enquiry that 'magnetism in the rocks affects the compass'. By way of a contrast, in the same location, the RAF air-sea rescue helicopter has sometimes been called in to rescue visitors stranded by the incoming tides.

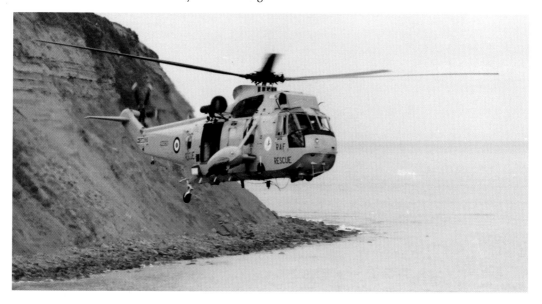

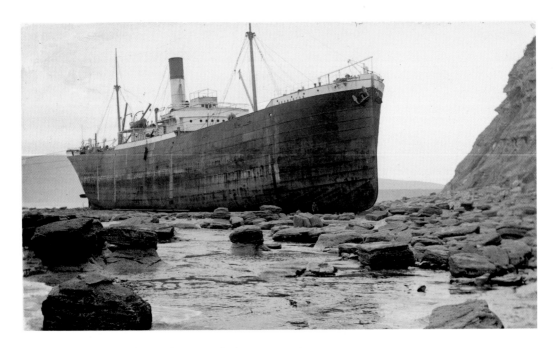

The *Hermiston* and the *Sarb-J* Stranded at Ness Point

The steam ship *Hermiston* of Glasgow ran aground near Ness Point in 1910. The second Robin Hood's Bay RNLI lifeboat, the *Mary Ann Lockwood*, landed two ladies from the vessel and rendered assistance. The rescued oriental seamen were to be seen outside the Bay Hotel eating a welcome meal with their chopsticks! The *Hermiston* was eventually towed into deeper water by four tugs. The recent photograph, taken in the same location, shows the latest vessel, the *Sarb-J*, stranded here. This trawler ran aground in January 1994 when its propeller became tangled by the fishing nets near Ness Point. The Whitby lifeboat tried to haul the trawler off but was unsuccessful, so the crew were taken off by helicopter. Salvage work has taken place, but the rusting hull is largely intact and is an impressive sight against the cliff.

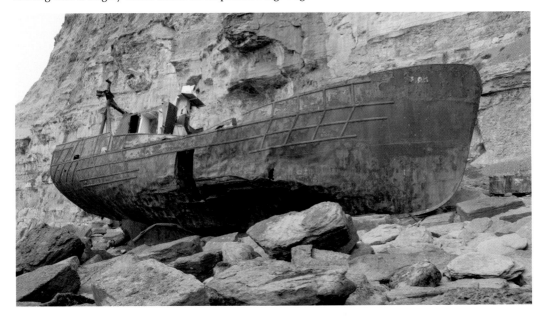

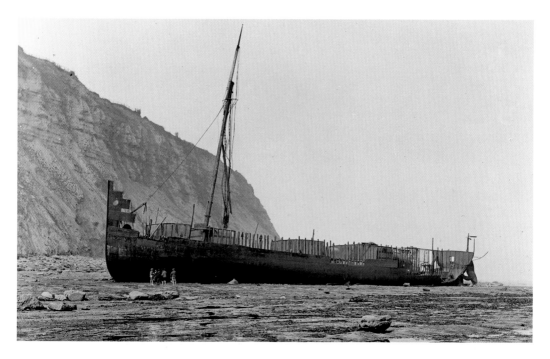

Dismantling the *Heatherfield*

The coaster *Heatherfield* ran aground at North Cheek in January 1936 in thick fog. The boat was about 200 feet from the cliff and inaccessible to the lifeboat. The Rocket Brigade fired a line to her and most of the crew were taken off by breeches buoy. The vessel was carrying a cargo of 450 tons of scrap iron that was retrieved by a salvage vessel. The rusting, but unidentifiable, relics of past disasters can still be found amongst the rocks at North Cheek.

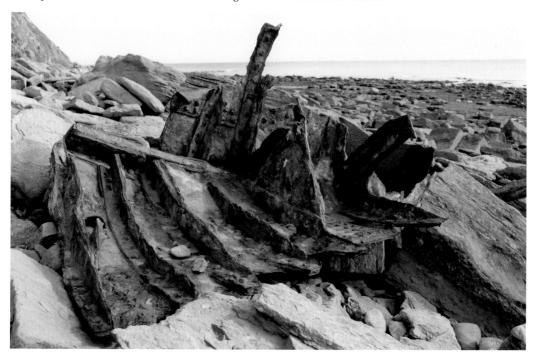

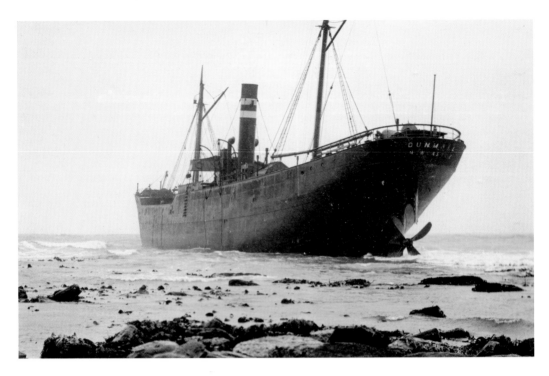

On the Rocks

The *Dunmail* ran aground in fog on 29 March 1911 near Ness Point. The Whitby and Bay lifeboats took off most of the crew. The steamers rudder was ripped away by the rocks and she was badly holed. As well as being a graveyard for ships, this area was also a graveyard for Jurassic sea creatures and large slabs of rock can be found containing a profusion of fossils — especially of the scallop — dating back over 150 million years.

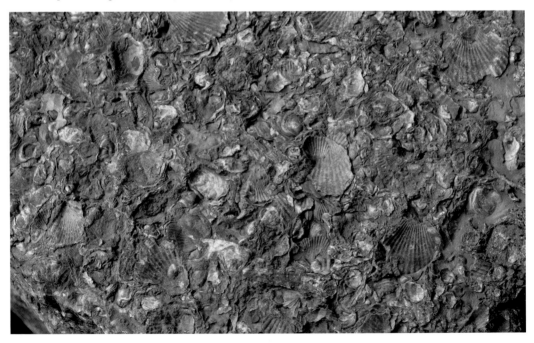

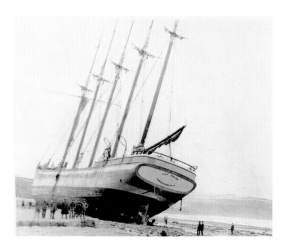

The Saga of the *Cap Palos*

The schooner *Cap Palos* was built in Vancouver in 1918. In June 1919, she sailed for Immingham with a cargo of timber. The auxiliary engine broke down on the way and it took three months to reach England via the Panama Canal. After unloading the cargo, the vessel was towed by two tugs up the east coast, but the tugs became stranded near Ness Point on 23 October. The following morning, the *Cap Palos* was blown onto the shore by gale-force winds and the crew rescued. The vessel was refloated nearly a year later, in October 1920. After temporary repairs in Whitby Harbour, she was again taken in tow, but another storm blew up, the vessel was blown out to sea and she was not seen for a few weeks. The crew of a fishing boat found her floating keel uppermost and a steam trawler was sent out and towed her to just off Scarborough where she sank and broke in two. One half of her was refloated and sold off for scrap; the other half was causing a hazard to shipping and was blown up! On its way to Whitby, where the recent photograph was taken, the replica bark *Endeavour* stopped in the bay for a short while, the first time a sailing ship had been seen in the bay for decades.

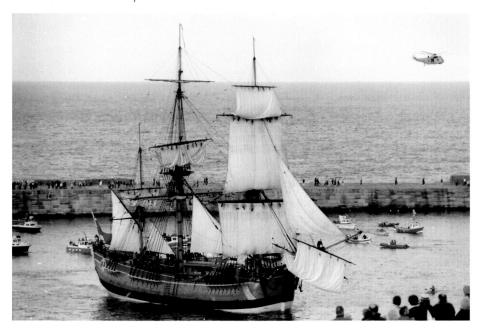

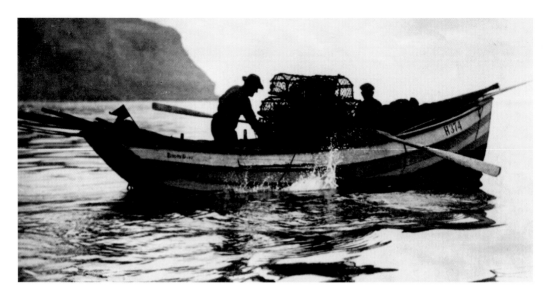

The Lobster Catchers

Crabs and lobsters were an important part of the fishing industry at Robin Hood's Bay. When the railway arrived in 1885, the fishermen found that they could send their crabs and lobsters inland to achieve much higher prices. In order to make it worthwhile, they needed to send them in quantity, so they cut holes in the rocks, known as 'keeps', as a way of keeping them alive and fresh until they had enough to send off by train. The 'keep' in the photograph has planks for a lid, and these are kept from floating away when the tide came in by the large slab of rock next to the basket. Traces of the keeps can still be found in the rocks.

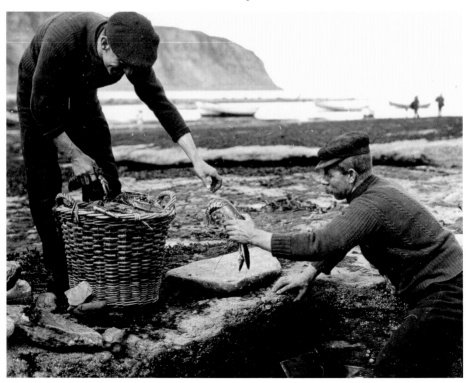

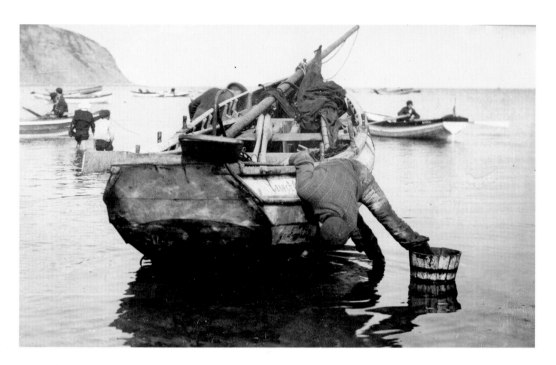

The Craft of Fishing

The coble was the mainstay of the village fishing industry. In 1820, it was said that 'the quantity of fish which is dried at Robin Hood's Bay, as well for home consumption as for exportation, is surprising. The fronts of its houses and the surface of its paddocks are often covered by them as they are spread to dry.' Although classed as rowing boats, cobles had a mast and sail that could be put up if the wind was favourable. A coble is now a rare visitor to the village.

Pots of Gold

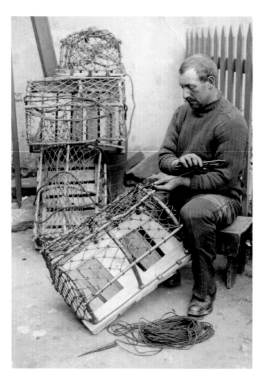

John Knaggs, a relative of the Dukes, making lobster pots in April 1914. At the height of its growth, at the beginning of the nineteenth century, the village had 130 fishermen with forty-five boats. By 1914, there were only two families fishing from the village — the Storms and the Dukes. The story of their trials and tribulations is vividly described in the book *Three Fevers* by Leo Walmsley, who once lived in the village. The village fishing industry was geared to include all ages and both men and women. Boys would help to mend nets and make lobster pots. When a man grew too old and stiff to face the long cold hours in the fishing cobles, he could change to lobster and crab fishing. The older fishermen carried on this type of work in both summer and winter, with as many as 300 pots carried on each boat. The women baited lines and helped haul up the boats. The pile of pots in The Dock confirms that crab and lobster fishing is still carried on in Robin Hood's Bay.

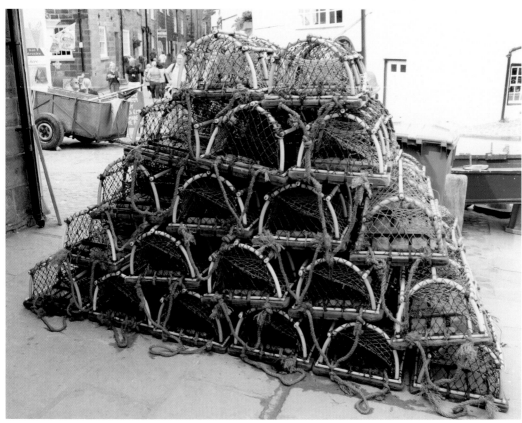

The Flither Lass

The flither lass was once a common sight on our rocky shores. Working their way up and down the beach, they collected limpets off the rocks. A sharp knife was inserted under the slightly open edges of the shells to flick them off before the limpet could clamp down on the rock. They were put in a sack that the girl carried on her back all the way up the beach, through the village and up the steep Bay Bank to the railway station. Sacks of limpets were sent off by train to be used as bait by the fishermen on the sandy shores of the East Anglian coast. One porter-signalman remembered sending sacks of limpets to Kings Lynn, 'Old Flither Lasses used to come, great big lasses, with water running off their clothes, smelt terrible!' On the recent photograph, the limpets and small barnacles wait patiently for the tide to return.

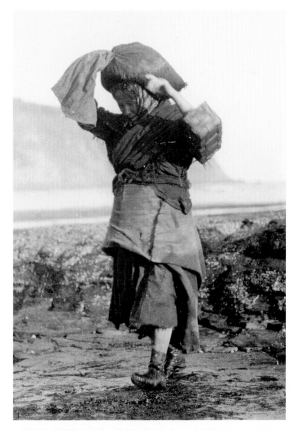

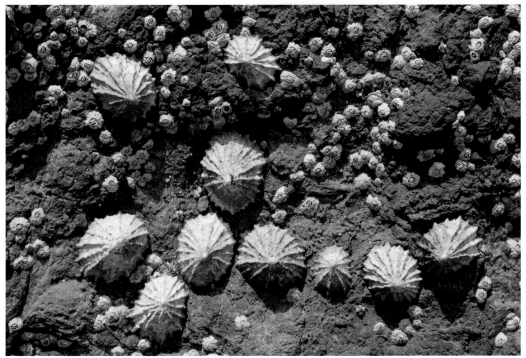

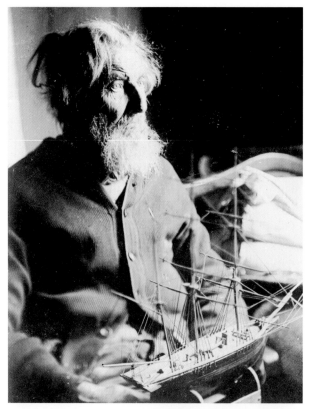

Knotty Problems

A retired 'Ancient Mariner' of Robin Hood's Bay proudly displays his handiwork. Many mariners, sailors and fishermen turned their hands to making models of their favourite boat or ship or demonstrated the complicated art of knotting that had served them so well during their lives at sea. The skills of knotting were still being passed on to the younger generation and John and Han are both wearing the traditional gansey that was worn by the fishermen. Each family had its own pattern and they were knitted from oiled wool that provided a degree of water repellence that helped to keep them warm during the long cold hours at sea.

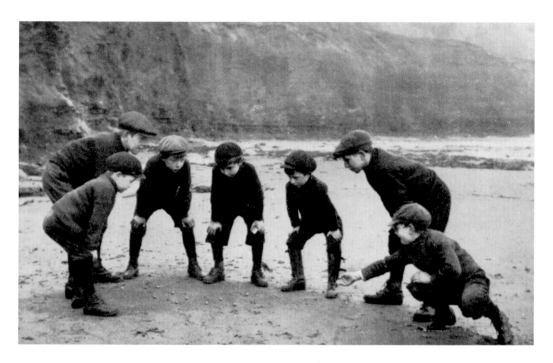

Fun and Games on the Beach

Robin Hood's Bay has always been a magical place for children, as the beach offers so many opportunities for play and exploration. The rock pools, with their fascinating creatures, provide another world to explore; the stretches of shingle and pebbles reveal fossils and agates in profusion; and the swathes of sand encourage a variety of games. King's Beck, flowing down the side of the slipway at Wayfoot, provides wonderful opportunities for building dams and ponds and time for parents to relax — until the tide comes in!

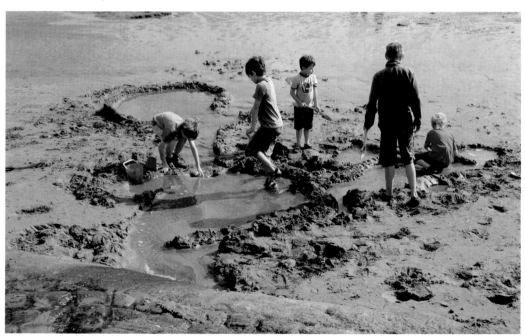

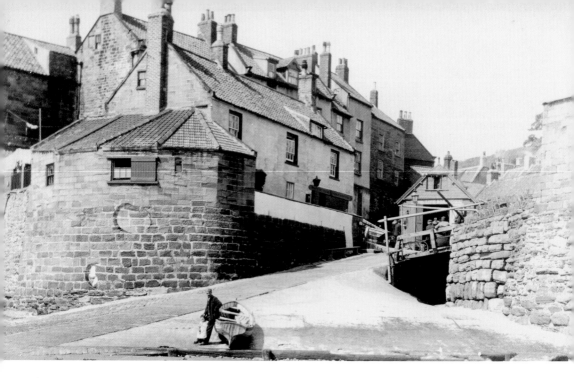

Wayfoot

The old coastguard lookout station, on the left, and on the right is the dark opening of the tunnel that brings King's Beck underneath the village. The coastguard building was demolished in the 1960s to make way for a new marine laboratory but this, in turn, was demolished to make way for the present National Trust Visitor Centre. The tunnel was regularly used by smugglers, as they could make their deliveries, unseen, into the cellars of some of the cottages and pubs that were connected by side passages.

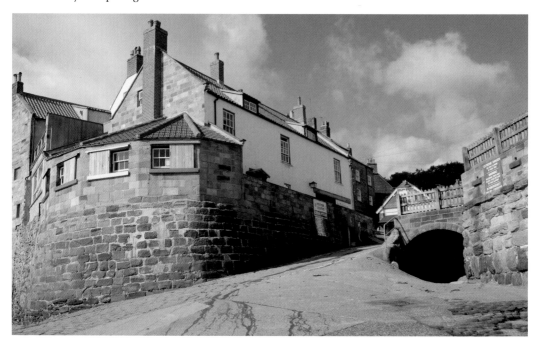

Tunnel Visions

The tunnel runs under part of the main street, New Road, and some of the cottages. It brings King's Beck down to Wayfoot and provided an ideal route for smugglers to secretly access the village and the surrounding area. It also provided an escape route for the men of the village when the press gang came to force them into the service of the navy. During the severe storms in the 1950s, it suffered from a battering by the sea when part of the roof, together with some of the road in The Dock, collapsed. Notice how close the arch of the tunnel was to the surface of the road. Many of the side tunnels have been blocked up in recent years, as is revealed on the right in the modern photograph.

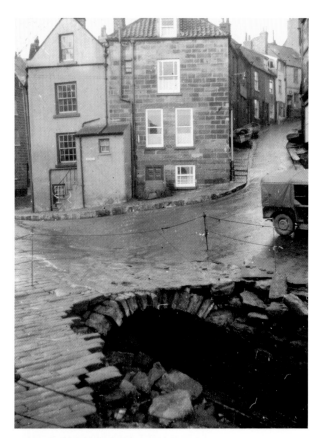

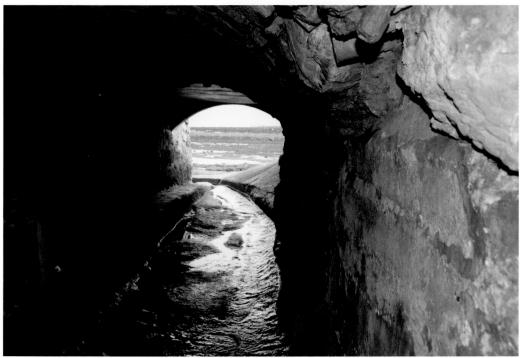

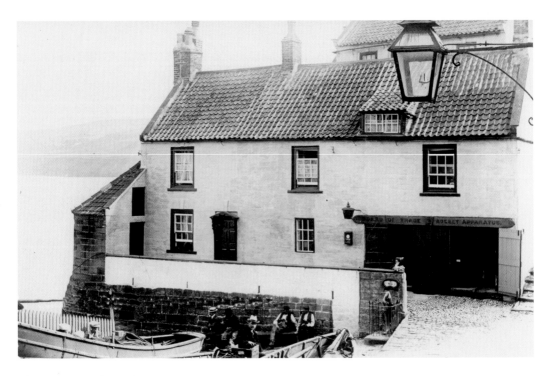

The Coastguard Station

From left to right, the building was comprised of the watch house, the coastguard's cottage and, behind the large wooden doors, storage for the Rocket Lifesaving Apparatus including the rocket cart. The old building was demolished in the 1960s to make way for a new marine laboratory, but this was bought by the National Trust a few years ago. They then largely demolished it and built a faithful replica of the old coastguard station that is now a National Trust Visitor Centre.

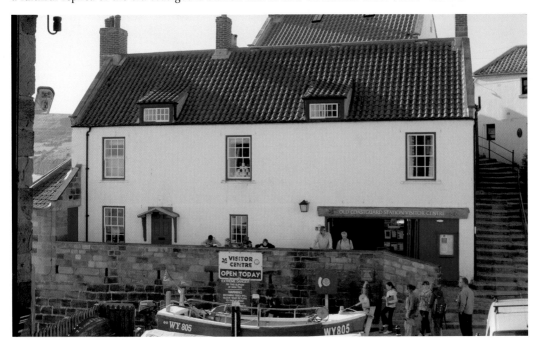

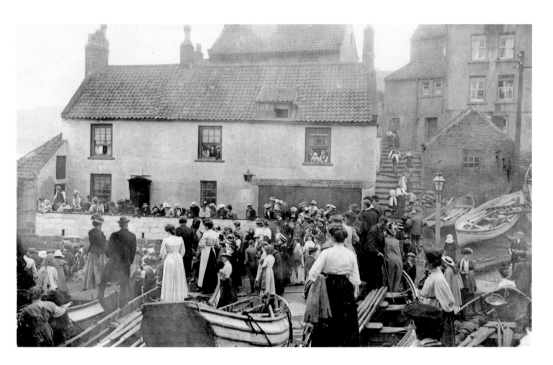

An August Occasion

The old photograph was taken on Lifeboat Day in August 1913. Lifeboat Day, always held on a Saturday in August, was a popular occasion both with visitors and residents. Note that the old coastguard station had closed, as new premises had been built for them above the old village. The sign above the large wooden doors reads 'J. Bedlington, Auctioneer & Valuer, House, Estate, Insurance & Commission Agent'. The recent photograph was also taken in August, whilst the visitors were eating their breakfasts!

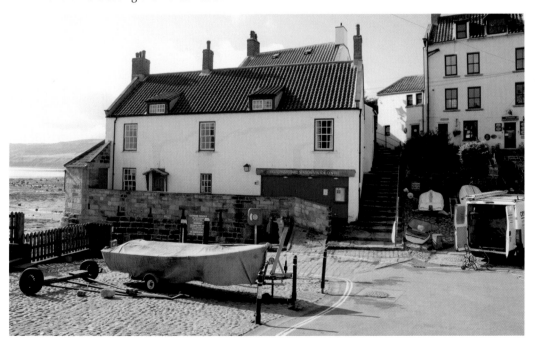

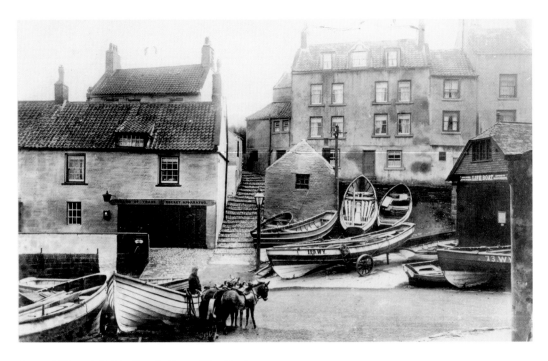

Covet Hill and Coble Heads from The Dock

In the centre of the old photograph, Covet Hill steps lead up to Coble Heads, the row of houses on the right, and continue on past the back of Beacholme and down to the Quarterdeck. On the left, the sign above the old coastguard station doors reads 'Board of Trade — Rocket Apparatus'. On the right is the Lifeboat House, now a public shelter and toilet. In the centre foreground, donkeys waited patiently for their young riders where cars now cause congestion.

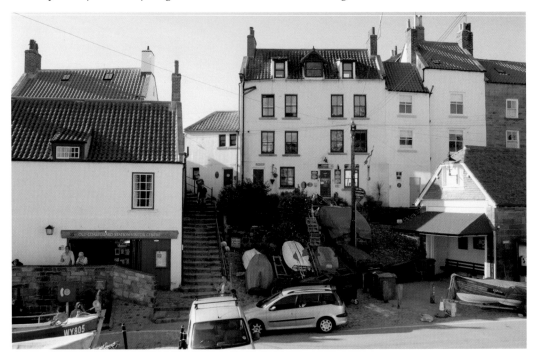

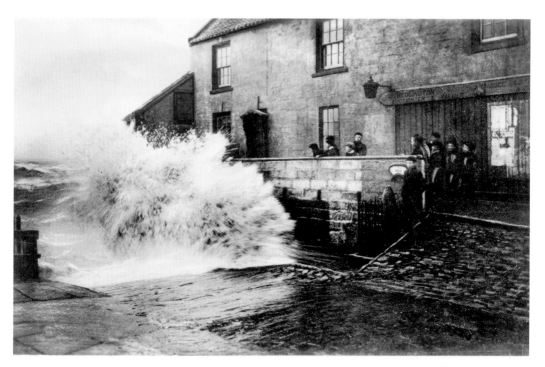

Stormy Times

Whilst the slipway at Wayfoot is normally a safe place, it can be very dangerous when high spring tides are driven even higher by north-easterly gales. This spectacular scene, being watched by a crowd of boys from behind the old coastguard station wall, was photographed in 1910. The Lifeboat Fish and its plaque can just be discerned behind its protective railing at the near end of the wall. The Lifeboat Fish is a giant moneybox in the form of a cod, with a slot in its mouth, which has been collecting money for the Royal National Lifeboat Institution for over 125 years. Children were told that if they put a penny in its mouth it would wag its tail, and if it did not, they were encouraged to try again!

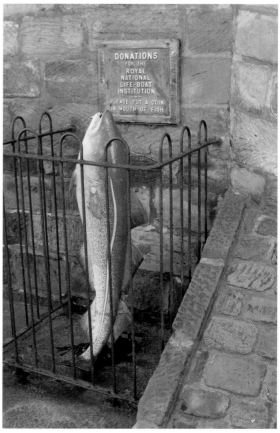

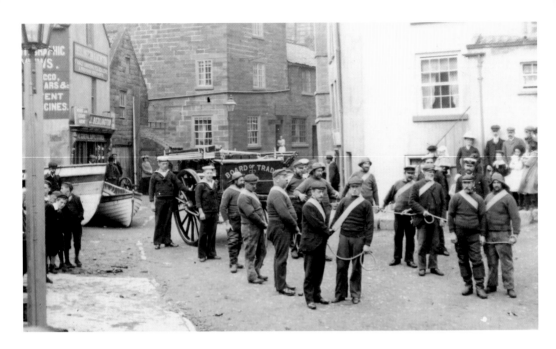

Every Man at His Post

The coastguards stand ready for a practice drill with their Rocket Cart in The Dock. The cart carried the equipment necessary to effect a rescue and consisted mainly of line carrying rockets, a breeches buoy and hawser. When a ship became stranded, the crew positioned their apparatus as close as they could to fire a rocket and line over the vessel in distress. Once the line was caught by the ship's crew, the hawser and breeches buoy could be hauled out and a rescue effected. *Inset:* A rocket is fired from the cliff.

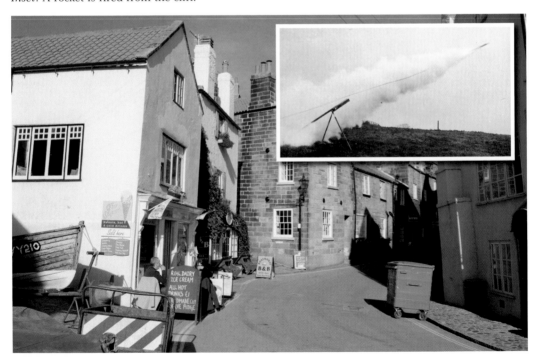

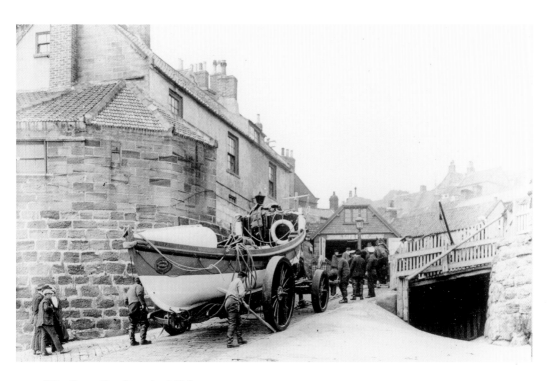

Wayfoot: Hauling the Lifeboat

The *Mary Ann Lockwood* lifeboat and its carriage weighed a total of 7 tons. The men behind the wheels have wooden wedges that were used to prevent the carriage running backwards if the horses lost their footing on the steep slipway. A few relics from the lifeboat have survived, including a lifebelt, carriage wheel and brake stick, and can be seen on display in the Bay Museum, which also has an interesting collection of relics, memorabilia and photographs illustrating the history of the village.

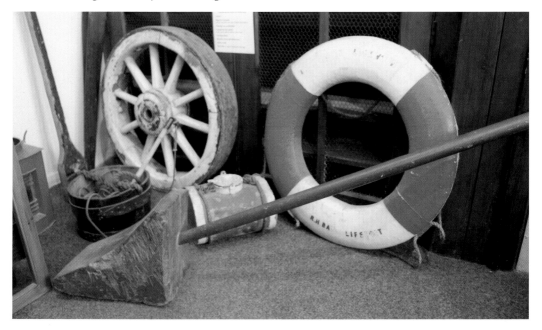

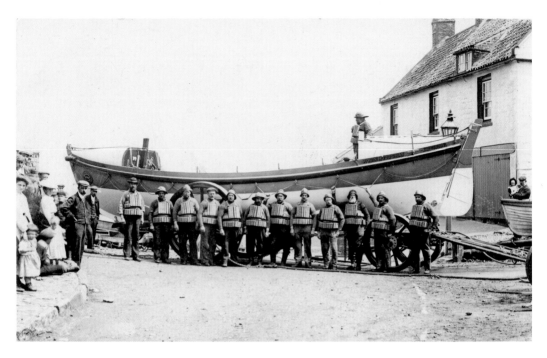

Reflections at Wayfoot

The crew of the *Mary Ann Lockwood* pose for a photograph on Lifeboat Day before it was carefully lowered down the steep slipway onto the shore. This was a difficult job that was done by hand as this lifeboat station did not have a tractor. Horses were brought from the local farms to haul it back up when it returned from duty. When the tide was out a team of men from the village had to haul it across the beach and into the sea.

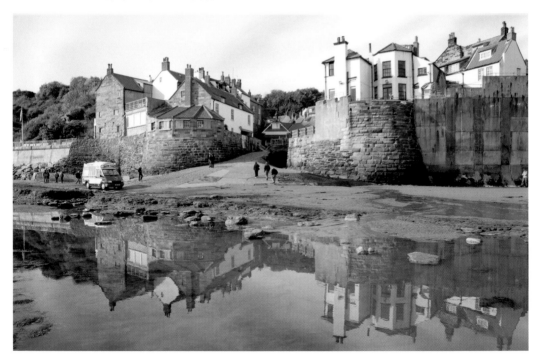

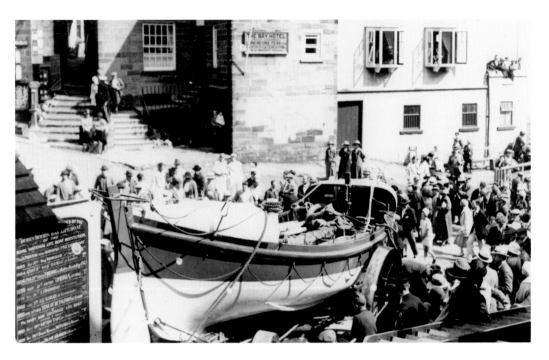

Lifeboat Days

Lifeboat Day in The Dock, with the second lifeboat, the *Mary Ann Lockwood*, installed in 1902, surrounded by a crowd of admiring visitors. Lifeboat Day was essentially a practice launch for the crew during the quiet summer months, but it was also a fund-raising opportunity for the RNLI. Lifeboat Day in the 1990s was a different affair, with the Whitby lifeboat attending and accompanied by an RAF air-sea rescue helicopter. The effect of the powerful downdraft from the helicopter on the sea was a remarkable sight.

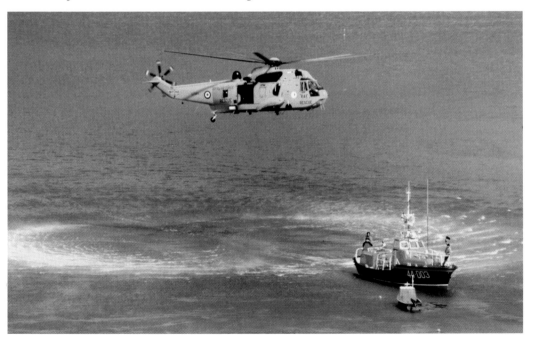

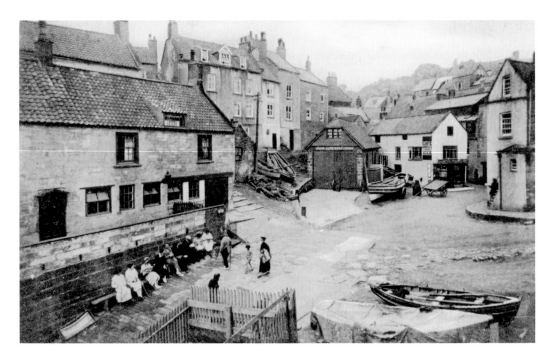

The Dock

The Bay Hotel provides a grandstand view of The Dock for patrons of the upstairs bar. The photograph, taken in about 1930, shows the old coastguard station after it was acquired by Leeds University and converted into a Marine Laboratory. New windows were put in on the ground floor and accommodation provided for the students. Beyond the lifeboat house is Howells Chocolate Shop that had a café on the first floor seating fifty people, a rare feature in a tightly packed village.

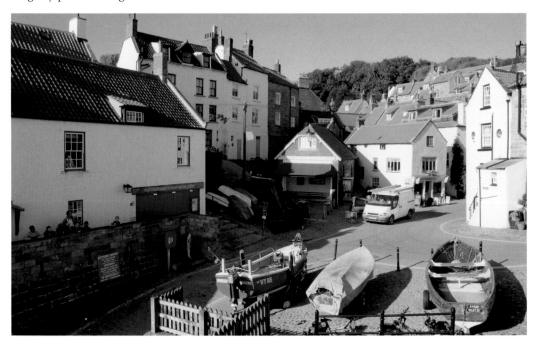

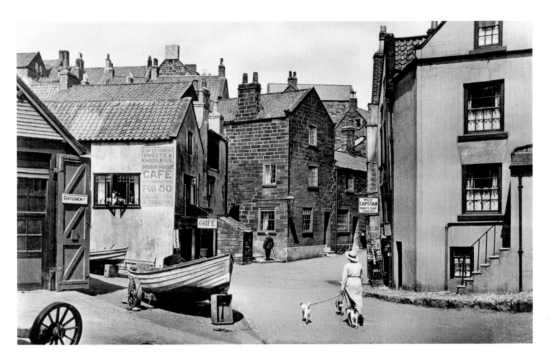

Providing Relief

The end of New Road from The Dock in the 1930s: the lifeboat station, on the left, had been closed and a sign, 'Gentlemen', on the door indicates that the building now provided relief for a different emergency! The old postcard photograph was produced for 'O. Storm, Newsagent, Robin Hood's Bay' and his shop is the one with the 'Capstan Navy Cut Cigarettes' sign hanging on the wall. In the modern view, the lifeboat house is still a public toilet.

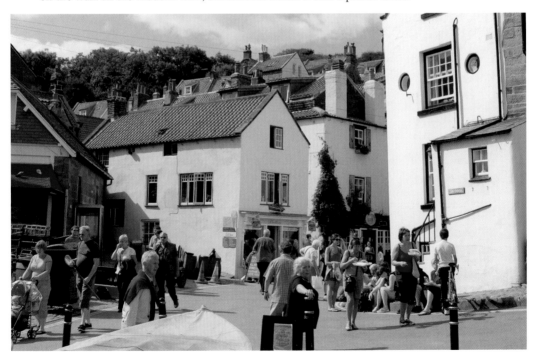

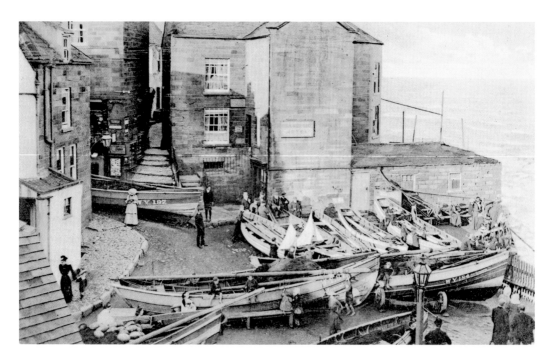

A Crowded Dock

The Bay Hotel, with its stables where farmers used to house their horses when they brought produce to sell in The Dock on market day. When Moor & Robsons Brewery took over the hotel in 1920, they immediately built a new wing above the stables to provide a larger bar and extra accommodation. A storm must have been expected when this photograph was taken — there are cobles every which way, even protruding from King Street! Now there are crowds of visitors enjoying the summer sunshine.

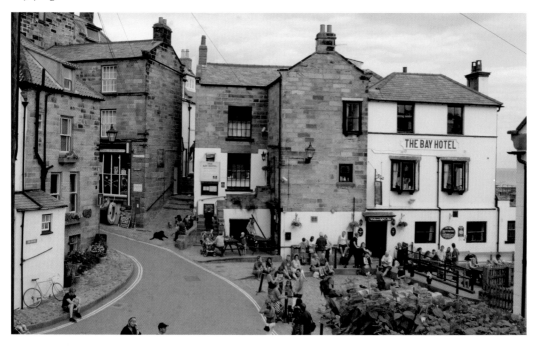

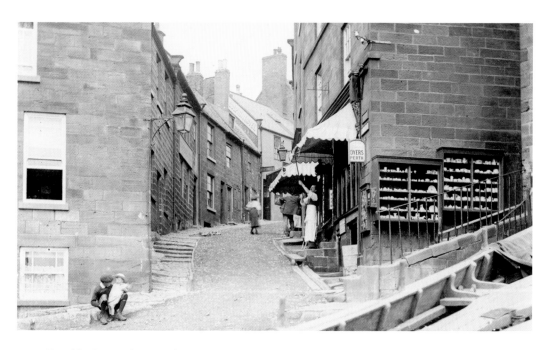

Seaside Souvenirs on King Street

The lower end of King Street, from The Dock, with W. A. Smith's Fylingdales Stores on the right. In his advert, in 1914, he advertised that the store stocked, amongst many other goods, 'Robin Hood China — Charming Souvenirs of Robin Hood's Bay — Great Variety of Shapes', and many can be seen in the cabinets on the wall of the shop. These have become collectors' items and a few are illustrated here, including the lifeboat fish, a candlesnuffer, a whelk shell and a coble.

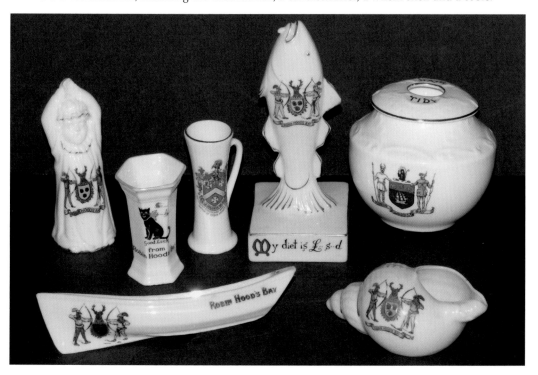

41

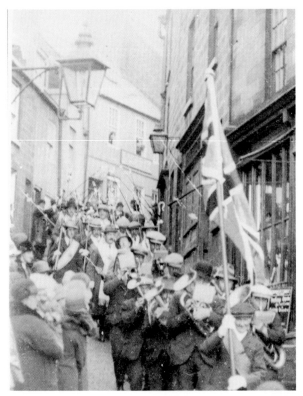

A Friendly Walk

There were three Friendly Societies in Robin Hood's Bay, and here the members of the Lodge of Ancient Shepherds, preceded by a brass band, march down King Street from Ye Dolphin Hotel, their headquarters, on their Annual Walk. In the 1861 Census, this street was listed as High Street, reflecting its former importance as the main street into the village until the cliff fall of 1780. In the 1860s, the Dolphin, at the top of the street in both photographs, was called the Masons Arms.

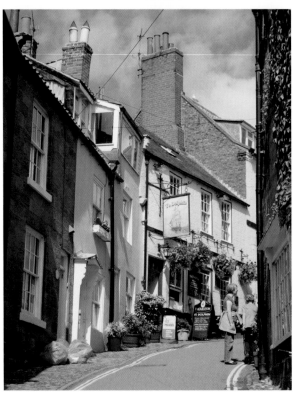

Popular Institutions on King Street

The top end of King Street, where the steps on the left once led into a narrow alleyway of cottages but now lead to the seawall promenade. The Men's Institute, pictured on the right, opened in 1919 to provide a place where a man could go to play a game of billiards or chess or have a quiet read or smoke. The Men's Institute had originally been the Kings Head Inn, up to 1890, when it became the teetotal Kings Head Temperance Hotel. In the recent photograph, early morning sunlight slants across the street and the Men's Institute is covered in scaffolding, whilst Ye Dolphin Hotel catches the morning sunshine.

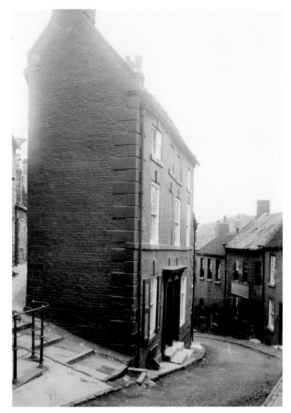

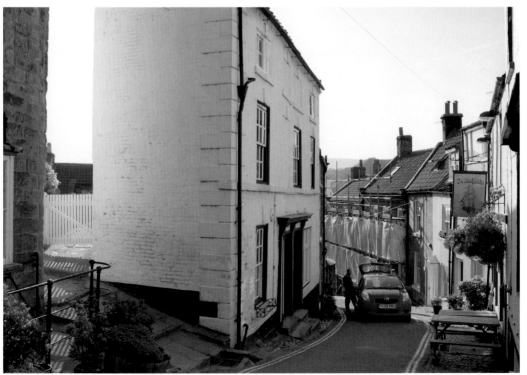

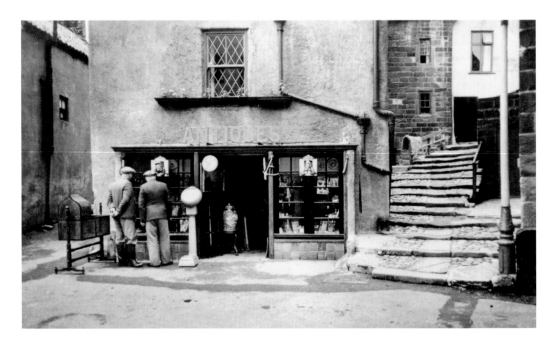

Old Curiosities

The Boathouse was once an antique shop and is now a bed and breakfast establishment on New Road near The Dock. At one time, it was an undertaker's parlour and later an amusement arcade! In 1911, Messrs Reuben Bulmer & Sons, joiners and boat builders, constructed Robin Hood's Bay's first pleasure boat here. Tyson's steps on the right lead up to Sunnyside, Littlewood Terrace, and Fisherhead, where the Robin Hood's Bay local history museum can be found in the former reading room and library.

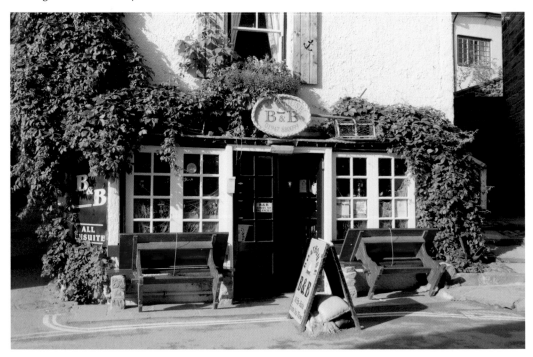

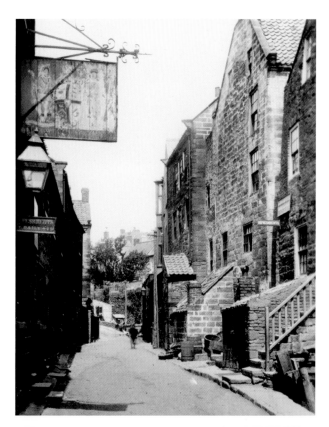

Signs of the Times

The lower end of New Road in about 1910: signs on the buildings advertise 'Refreshments', reflecting the growth of tourism. The large hanging sign advertises the Robin Hood & Little John Inn, thought to have been called the Nags Head Inn at an earlier period. Current signs include a 'for sale' notice and the board advertising the 'Robin Hood's Bay & Fylingdales Trust Museum of Local History'. Double yellow lines, whilst necessary in this day and age, do detract from the character of the old village.

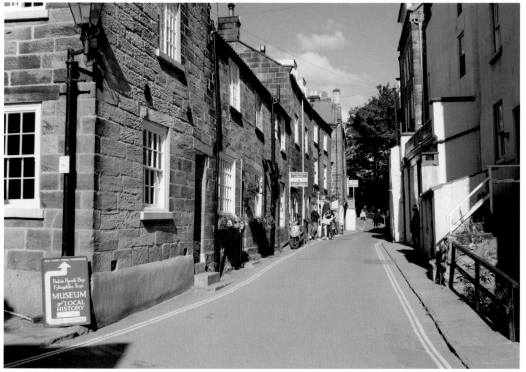

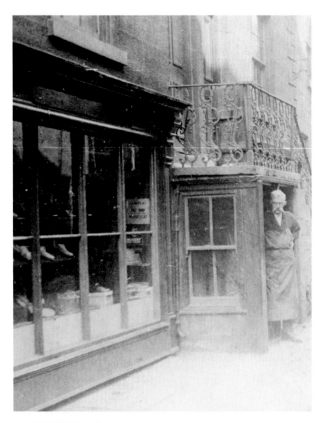

The Shoemakers Shop

Mr William Durant stands outside his shoe shop on New Road in about 1925. This was a coal warehouse at one time and later, after the shoemakers, it became the newsagent business of Bill Brown. Hazel Brown took over from her father and ran the business for many years, but the premises were sold recently and it is pleasing to see that the old cast-iron Art Nouveau railings, which had become very dilapidated, have been restored to their former glory.

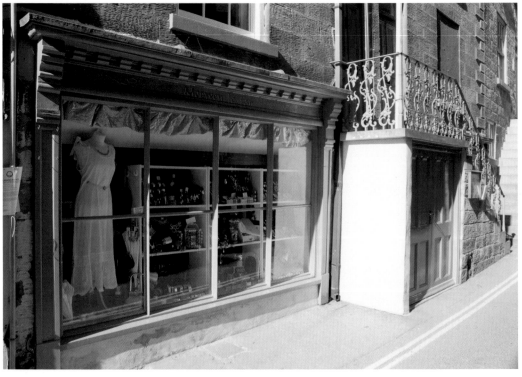

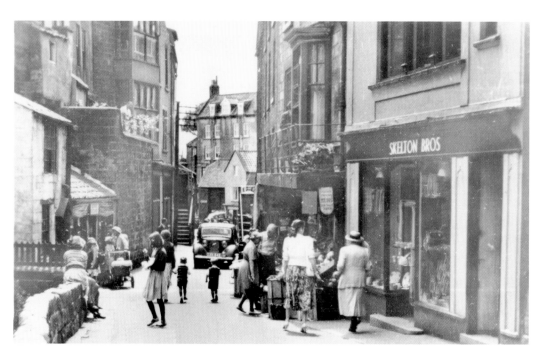

Temptations on New Road

A view down New Road, with Skelton's shop on the right and W. H. Brown's newsagent beyond. The recent view shows that Skelton's has changed into a shop with a very tempting chocolate fountain in the window and a giant ice cream cone outside — the old fishermen would have had a few wry comments to make about that! The old donkey house, on the left, metamorphosed into a two-storey shop selling fossils and minerals.

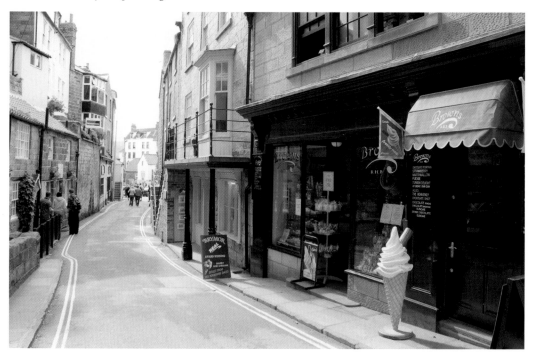

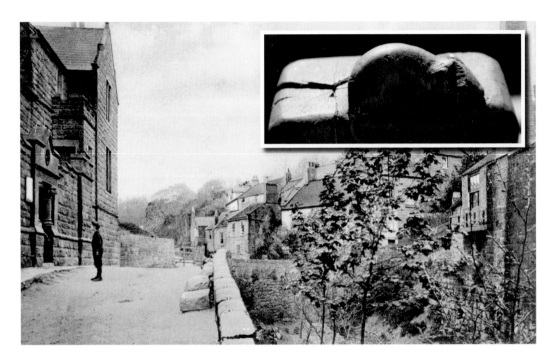

An Arresting View

This scene, near Bridgend, shows the houses and cottages of The Bolts in the distance. On the right is the old bakery, with its tall brick chimney, overlooking King's Beck. On the left is the Robin Hood's Bay police station, built in 1886. The recent view shows the entrance to the police station, long since closed. The wooden gate was carved by the famous 'Mousey Thompson' of Kilburn, whose high-quality oak furniture was always 'signed' with a mouse, which is on the top of the gatepost. *Insert:* the carved mouse on the top of the police station gatepost.

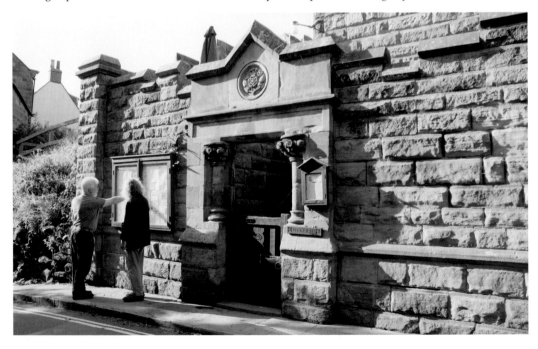

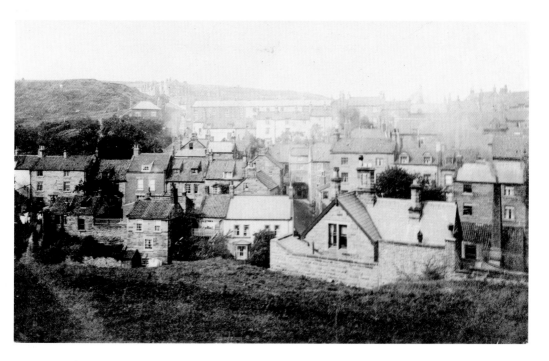

A Perfect Picture

The top half of the old village as seen from Fisherhead. On the extreme right is the tall, gently smoking chimney of the old bakery. The large building in the right foreground is the back of the old police station. On the left in the recent view, a local artist paints a picture of the old pantiled cottages long popular with artists and photographers. On the right, the chimney of the old bakery, now a tearoom and café, is not the landmark it once was.

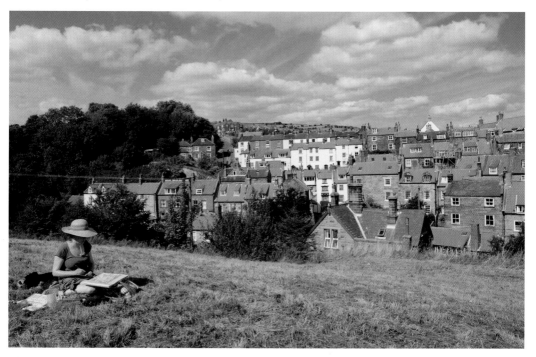

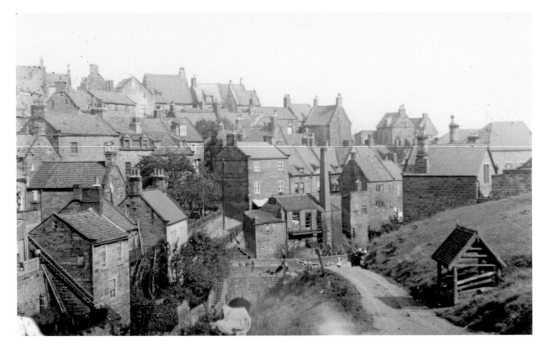

What's Cooking?

Near the centre of this old photograph is the tall chimney of the old bakery. Housewives could take their joint of meat and vegetables to be cooked in the oven for 1d. The road on the right leads up to the National School and continues up to the new Coastguard Station that opened in 1912. The wooden 'hut' on the right was where churns of milk from the local farm were left for collection; it is now a parking space for one car!

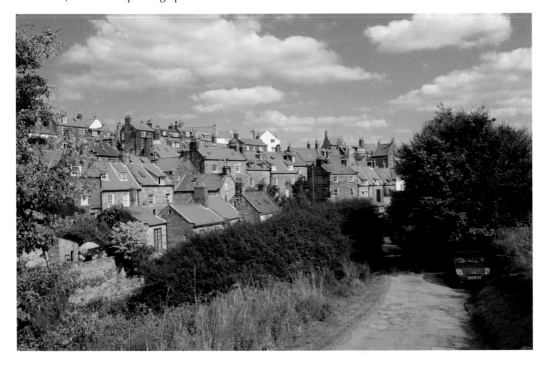

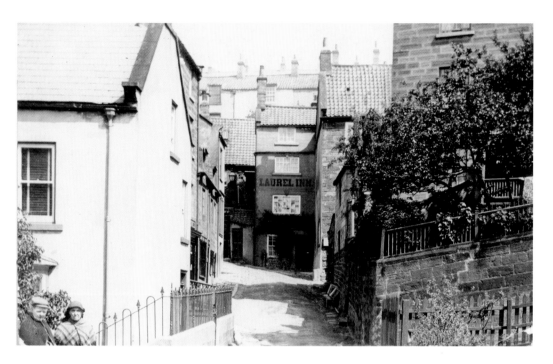

The View from the Bridge

The steep Bay Bank levels out as it approaches Bridgend. The Laurel Inn, in the centre of the old photograph, has kept the same name for over 150 years. On the left in the recent photograph, the opening gives access to The Bolts that may have been used in the past by the men of the village avoiding the press gang and a hard life in the navy. The shop beyond the opening is Muir Lea Stores, once the Supply Stores of Andrew Storm around 1914.

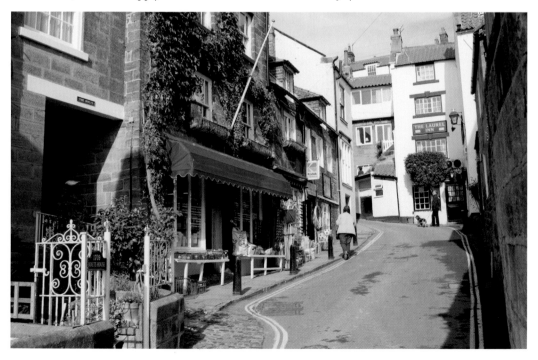

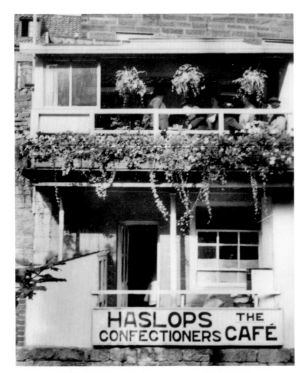

Small Change at the Bakery

The Old Bakery has seen many changes and this view from the 1930s shows the open balcony that was very popular in hot summers. During the Jubilee Celebrations of 1935, Haslops provided the 600 teas to feed the participants in the sports field at the top of The Bank. The cost of each tea was 6*d* (2.5p) but children were free. The trees alongside King's Beck obscure the view, so the recent photograph was taken from the bridge at Bridgend.

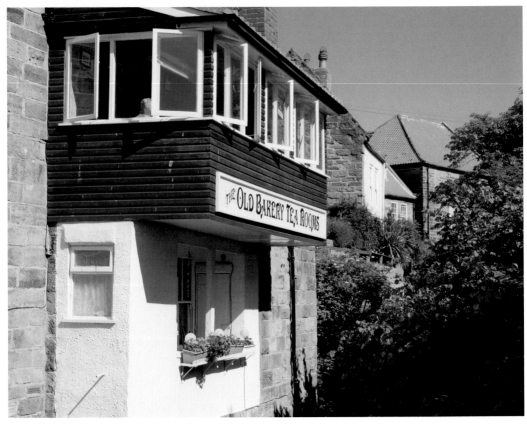

Butcher, Baker...

A view from the northern end of Chapel Street, originally called Low or Lower Street when King Street was called High Street before the cliff fall of 1780. On the left is T. Fewster, butcher, with meat displayed in the open air. On the right is the Old Bakery, which is now a tearoom and café, with views over King's Beck and New Road, opposite the old police station. The butcher's shop became a pottery in the 1980s and is now the Robin Hood's Bay Bookshop.

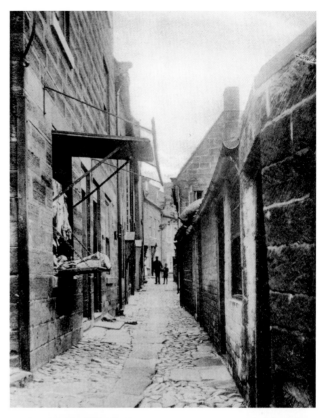

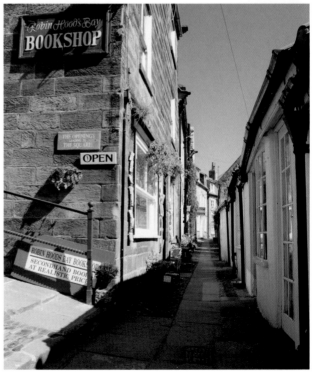

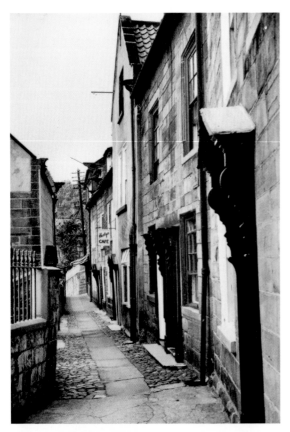

... and Candlestick Seller!

Chapel Street looking back towards the bakery and bookshop. The gable-ended Wortley Cottage has a sign hanging from the wall reading 'Haslops Café' and was an overflow annex to the café. Opposite the annex is Roseberry Cottage, perched on the edge of the small ravine carved out by King's Beck. It was one of a number of cottages on that side of the street, most of which have tumbled into the beck. Later, Wortley Cottage became an artist/photographers studio and then, until recently, an antique, curio and collectables shop called Valeriana, selling the occasional brass candlestick!

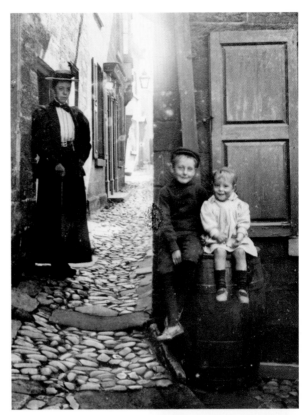

Sunny Smiles and a Stern Stare! Tommy Baxter Street was once called Apple Tree Row but bears its present name from a former resident of the street. Dame Ethel Walker, the famous artist, lived in a cottage near the end of the street for twenty-five years. She embarrassed the local fishermen by going 'skinny-dipping' from their boats! The cottage, behind the two small boys sat on the water butt, was once the home of Will Turnbull, the bellman or town crier, but it was demolished and gave the cottages on the left a much more sunny aspect.

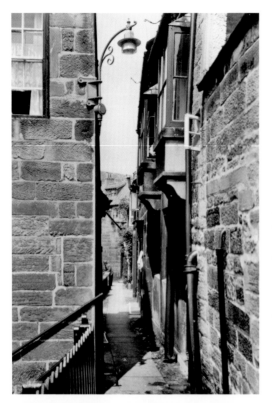

Tommy Baxter Street

There are so many quaint streets, picturesque corners, and enchanting views in the old village that it is hardly surprising it is so popular with artists and photographers, who find a wealth of visual delights in the place. Surprisingly, some visitors ask the whereabouts of the betting office or the amusement arcade! The old electric street-lamp is a rare survivor here, appearing on both old and new photographs. All the streets in the village were once lit by gas.

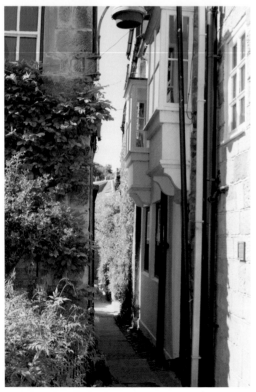

Carrying the Cans

The Openings, one of the most popular locations for artists and photographers, is seen here with Reuben Storm delivering paraffin round the village. Until 1932, when the electricity grid was connected to Robin Hood's Bay, lighting in the cottages was by paraffin lamp. Reuben sold about 70 gallons a week, all of it carried on his shoulders. The wedge-shaped building in the centre was once a fish and chip shop and was about to acquire a dormer window when the recent photograph was taken.

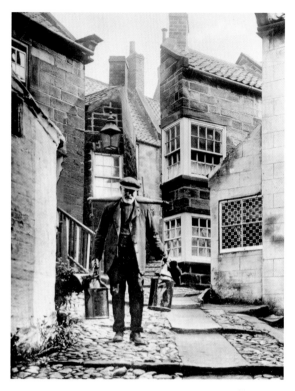

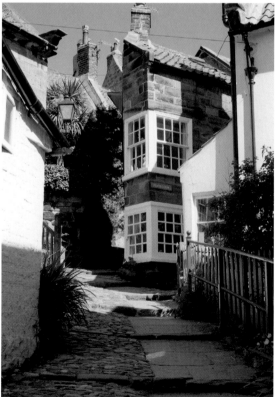

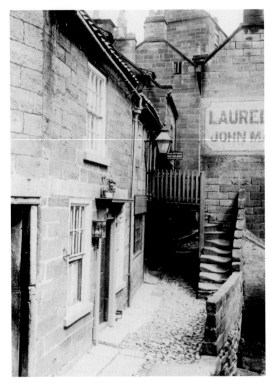

House of Martin

Martin's Row, down the side of the Laurel Inn, was so named from the family that lived here. John Martin was the licensee of the Laurel as well as being the village blacksmith. The door of his smithy is on the extreme left and he lived with his family in the cottage next door. Above the window of the cottage, the words 'J. Martin, Farrier' can just be made out on the original photograph. A farrier was a blacksmith who was also skilled in the making and fitting of horseshoes and would be kept very busy when virtually all transport was horse-drawn. John Martin's father, Edward, had been a blacksmith before him, as had his grandfather, John, before him, in 1851. The sign next to the lamp at the top of the steps to Gallery Cottage reads — 'John Jefferson, Boot & Shoemaker — Repairs Promptly Executed'. Jacky Jivvy, as he was called, was a jack of all trades and also swept chimneys, and he was also the village lamplighter when all the street gas lamps were lit by hand. It is not difficult to work out which lamp was lit first!

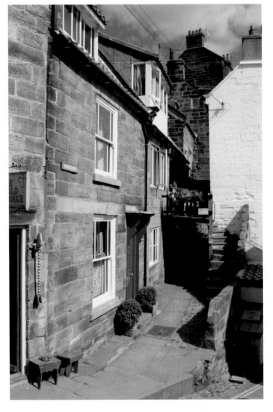

Water of Life

The Laurel Inn at the bottom of the steep Bay Bank when Margaret Martin had taken over as licensee. The Laurel has a bar that is cut out of the solid rock with a 'barrel' roof. Before water was piped to the individual cottages, there were permanent stand pipes located in various streets round the village. One of the standpipes can be seen in this photograph, in its ornate cast-iron housing, in the foreground. The recent photograph also shows the entrance to The Old Forge that is now a gallery selling artwork.

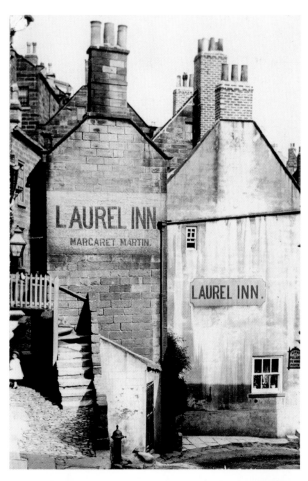

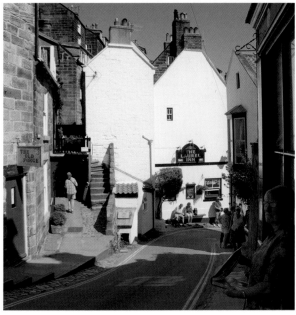

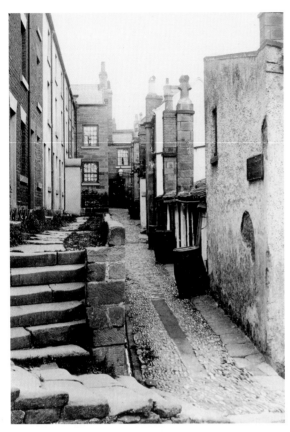

Esplanade Fronts and Bloomswell Backs

A view from Bay Bank along the Esplanade and the backs of the cottages on Bloomswell: the cottages on the left were some of the last to be built and date from around 1850. The building on the right was demolished many years ago and replaced by the building seen on the recent photograph. It was once a branch of the Midland Bank but only opened for half an hour on Thursday afternoons. The row of rainwater barrels has been replaced with the not-so-attractive wheely bins.

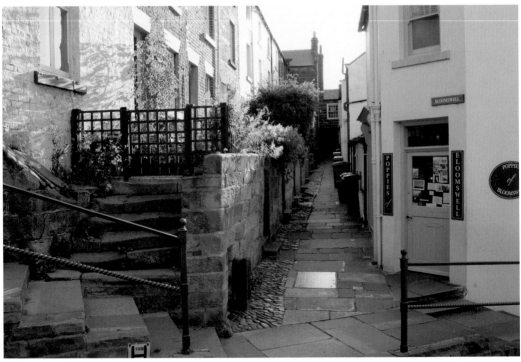

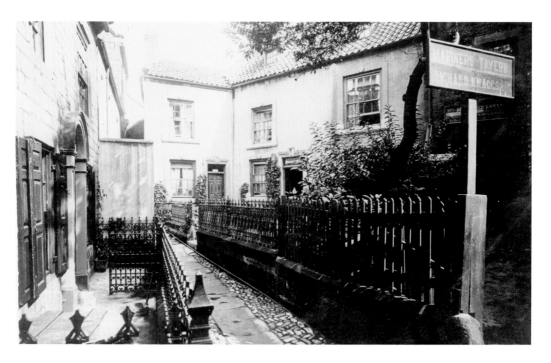

Not So Square!

Cottage owners know from experience that there are very few right angles in the cottages or the streets. The Square, despite its name, is no exception! On the right is the sign advertising one of Robin Hood's Bay's many pubs, the Mariners Tavern, licensee Richard Knaggs. The Mariners Tavern was reputed to be the haunt of smugglers in the eighteenth and nineteenth centuries. Many cottages had small wooden or brick-built earth closets outside but they too seem to have been replaced by wheely bins.

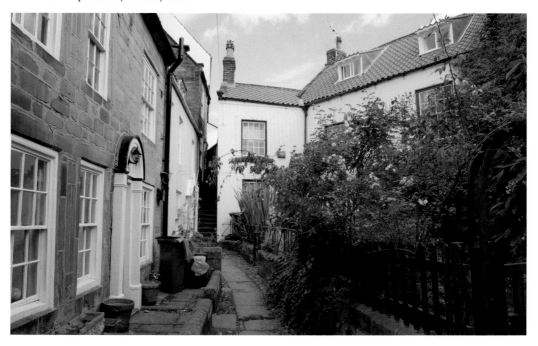

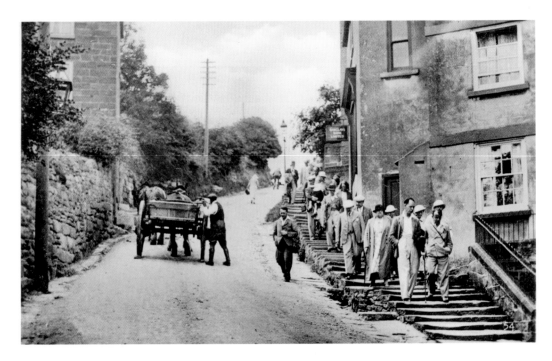

A Hill Climb

Crowds of people descend Bay Bank in the summer months on the way to the beach. When they return at the end of the day, the road seems much steeper and the steps longer than when they came down. New railings have helped and cars speed up and down where horses once struggled up the unmade road. Holidaymakers used to write home complaining about Bay Bank — 'It's all steps here, 98 at one stretch to get to the bottom of one street.'

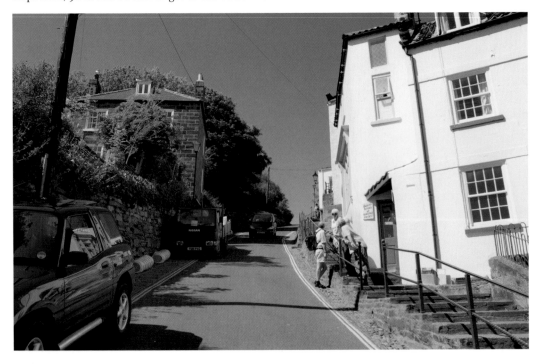

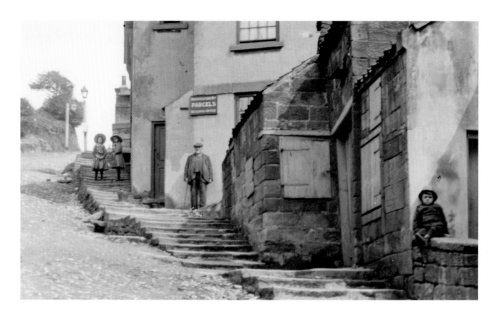

Strain Relief

Detail from an old photograph showing part of Bay Bank and the sign for the North Eastern Railway Company's Parcels Receiving Office. This was opened in 1904 and provided a useful facility for residents and visitors, as they could take their parcels, trunks or suitcases to the office and they would be conveyed up to the railway station by horse and cart. There were two out-porters running this service, for which they were supplied with a very splendid brass armband to wear when on duty.

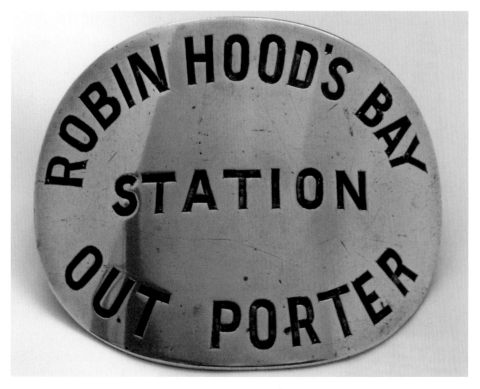

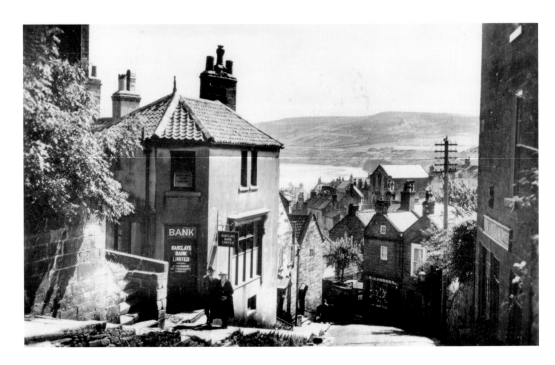

Three Banks

A view down Bay Bank with a branch of Barclays Bank on the left and a branch of the Midland Bank on the right. The former is now Poppies and the latter the Treasure Chest, an appropriate name for a former bank! In the distance, the large building is the former Congregational Methodist church, opened in 1840 but now recently closed. John Wesley came to preach in Robin Hood's Bay a number of times between 1757 and 1784 and had a strong following in the area.

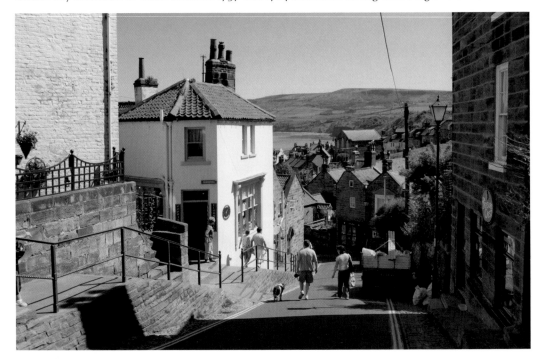

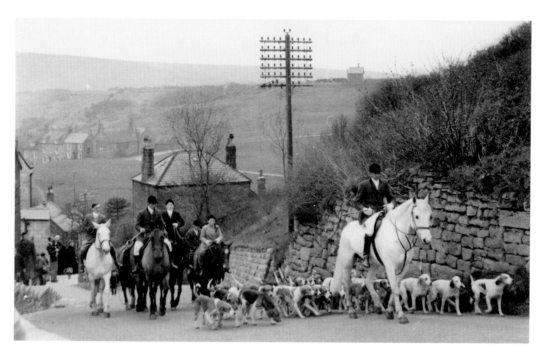

Horses and Riders

The Staintondale Hunt, climbing Bay Bank, was a regular visitor to Fylingdales on account of the varied nature of the countryside — ideal fox country. For forty years, the Turners (Bob, Len and Jane) ran their ponies along the beach giving rides to children. Keen riders and adults could accompany them on extended rides through the local countryside. The author recalls riding one of their horses, a 17-hands-high black mare, down the steep Bay Bank — a very memorable experience for a novice rider!

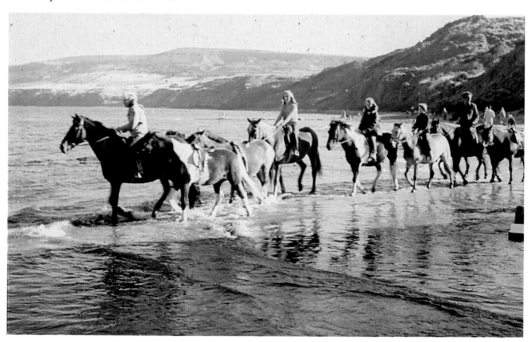

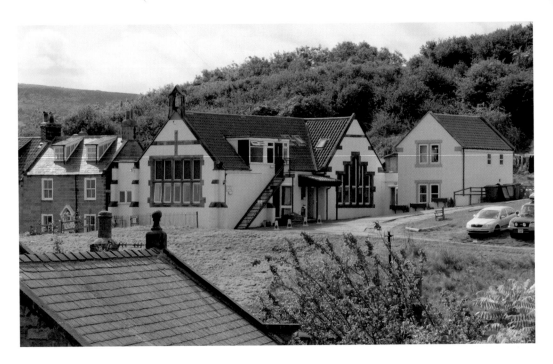

The Robin Hood's Bay National School

The school, in the centre of this photograph, was built in 1861. Girls, and boys up to the age of eight, were taught here; older boys went to school at Fylingthorpe. The custom of crowning a May Queen was revived by the vicar, the Reverend Jermyn Cooper, in 1862. The girls went in procession round the village, visiting the homes of the important residents, and they are seen here climbing Bay Bank. As a hostel, the building now provides excellent accommodation for school parties on residential visits.

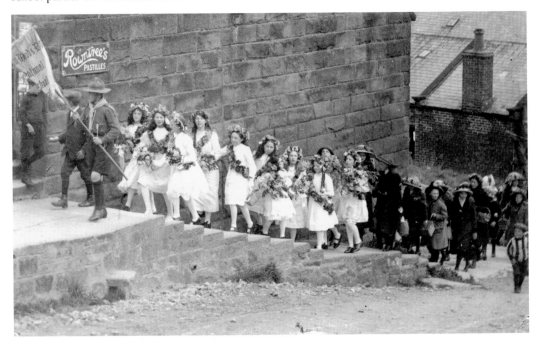

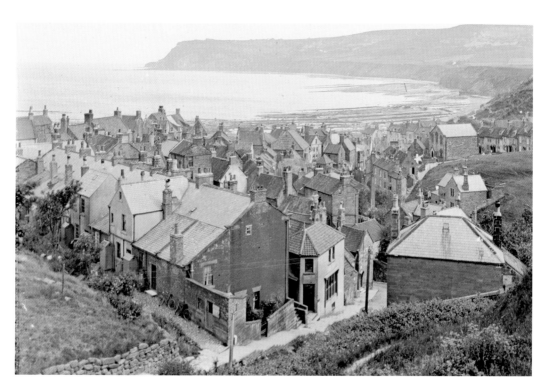

The Esplanade near Bank Top

The view over Robin Hood's Bay from near the top of Bay Bank. The Esplanade, the street of cottages on the left, had an orderly row of outside earth closets from which it got its popular local name of Sentry Box Row! Many cottages and houses have been altered and extended over the years and the one on the corner of the Esplanade has had a rear second storey added as well as an extension into the yard adjacent to Bay Bank.

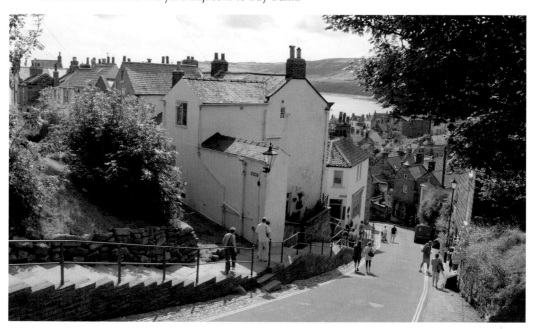

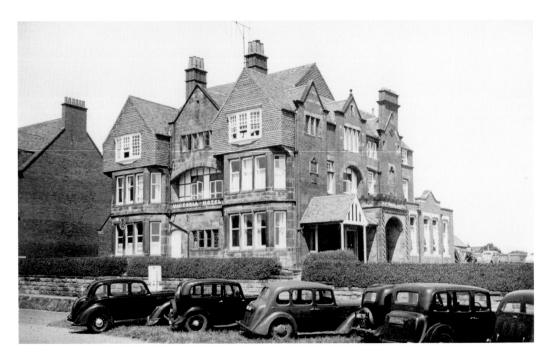

The Victoria Hotel

The Victoria Hotel on Bank Top was built in 1897. The only major change appears to be the family room extension on the left side. The dining room extension, on the right, had been added earlier and does not appear on the old photograph on the next page. The hotel was described in the 1920s as being situated in the healthiest part of the village, probably an allusion to the fact that King's Beck was an open sewer, with rats to be seen regularly on its banks!

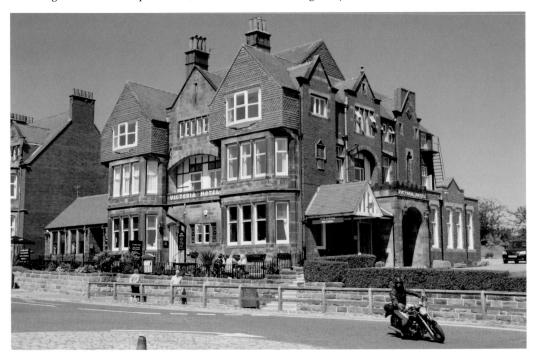

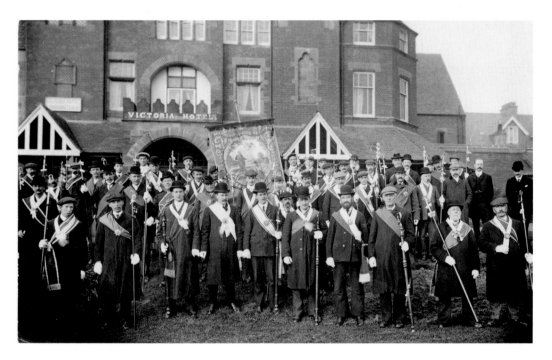

Friendly Societies

Members of the Shepherds Lodge in front of the Victoria Hotel at the conclusion of their annual walk that started at Ye Dolphin Hotel on King Street. Friendly societies were formed to look after the health and welfare of their members in the days before the NHS, each member paying a weekly subscription. There were three Friendly Societies in Robin Hood's Bay: the Shepherds, the Oddfellows and the smaller Robin Hood & Little John Club, whose banner can be seen in the museum here.

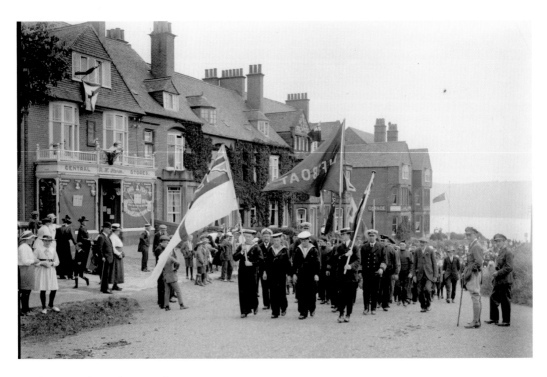

Bank Top and Station Road

The impressive terrace of houses leads down to the Victoria Hotel: many of the master mariners in the old village aspired to a property here or on the Mount Pleasant Estate in their retirement. The older photograph was probably taken during the Peace Celebration Day celebrations that were held in 1919 to mark the first anniversary of the ending of the First World War. On the left, R. K. Storm's Central Stores has become the Wayfarer, catering for the bed and breakfast visitors.

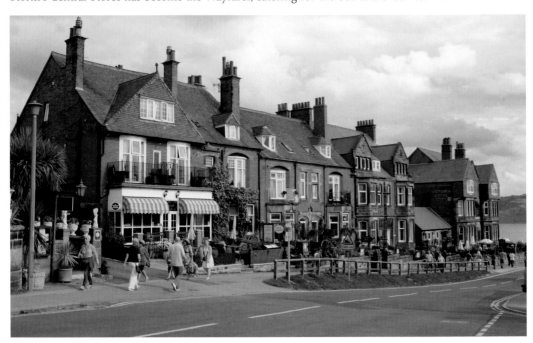

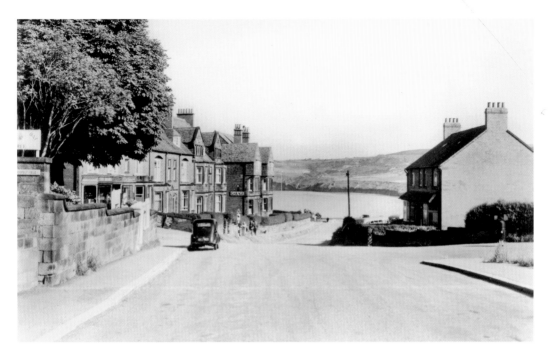

Station Road

Some things appear not to have changed, but nearly all the houses on the left were once private residences and now provide accommodation for visitors. The name of the road is now long out of date as the railway closed in 1965 as a result of the Beeching Axe, when many small branch lines in Britain were cut. The station site has been converted to a car park. Thorpe Lane, on the right, has seen the greatest changes in the last century (see page 85).

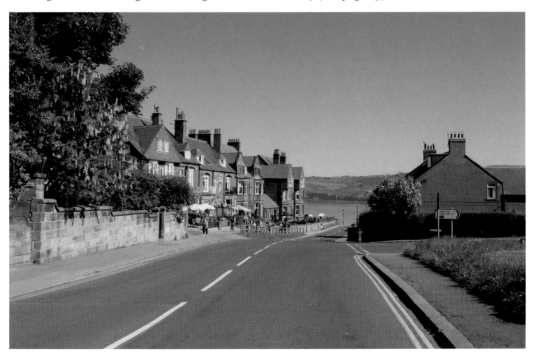

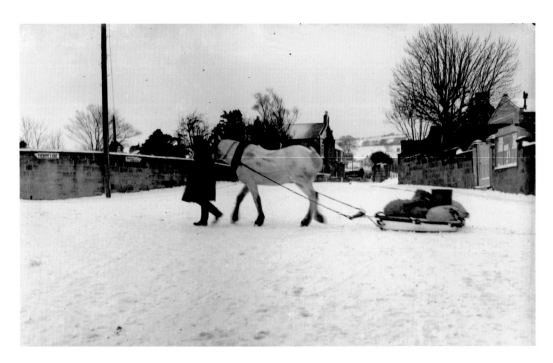

Transports of Delight!

A very wintery old photograph provides a contrast in transport at Thorpe Lane: in the days when virtually all transport was horse-drawn, getting around the steep hills in snow was probably easier than by car. In Victorian times, prior to the arrival of the railway in 1885, the village had two carriers who ran daily services to Whitby and back with their horse-drawn covered wagons. Now the village has the No. 93 bus, going to Middlesbrough via Whitby, which is very popular with summer visitors.

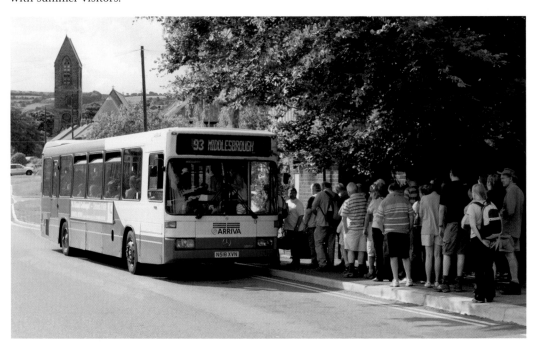

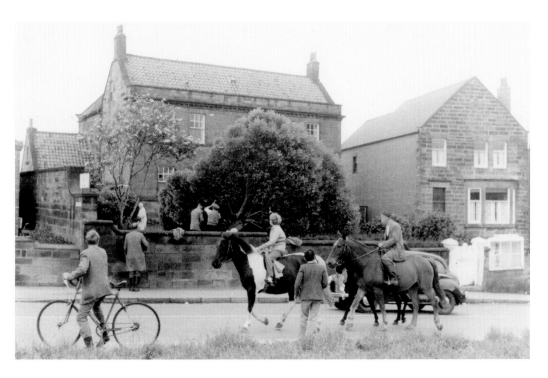

The Bay Tree

The Bay Tree, now an elegant home for the elderly, is situated opposite the end of Thorpe Lane. As the old bay tree, from which it got its name, is cut down, passers-by on Station Road pause to watch the spectacle. A colourful laburnum tree now stands in for the old bay tree, but the name of the house has not changed! Next door, The White Owl guest house has acquired a balcony so that guests can enjoy the afternoon sunshine.

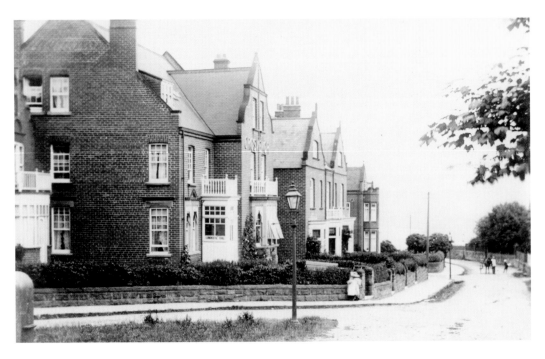

The Grosvenor

The Grosvenor Hotel was part of the Mount Pleasant building estate that comprised three roads: Mount Pleasant North, East and South. The fourth side of the rectangular estate is formed by this row of buildings fronting onto Station Road. The photographs were taken from the entrance to the railway station yard, now a coach and car park. In an advertisement of 1894, the estate was advertised as being within 200 yards of the Robin Hood's Bay station of the Scarborough & Whitby Railway.

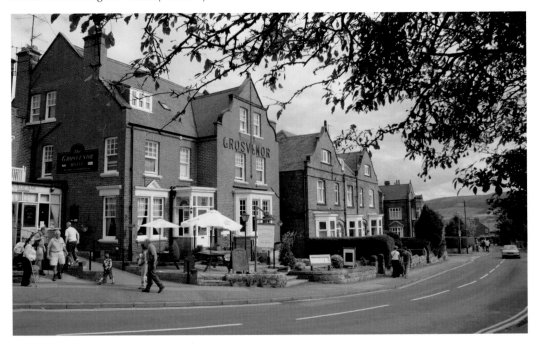

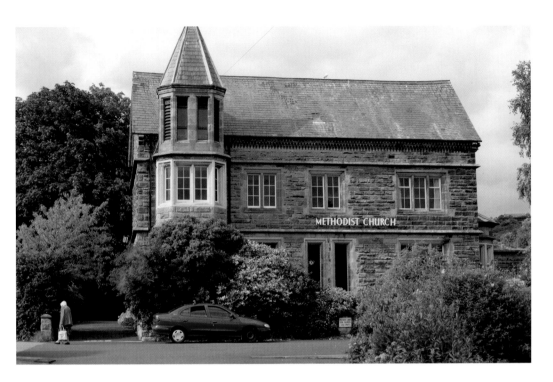

The Manor House

The old Manor House, Wesley Road off Thorpe Lane, was converted to a Methodist church in 1935 but was formerly occupied by one of the major local landowners, Sir Charles William Strickland Bart., lord of the manor. The old photograph shows the staff at the Manor House in January 1907. It also confirms that the original front door, on the left, was replaced by the pair of vertical windows, seen beneath the word 'Methodist' in the recent photograph.

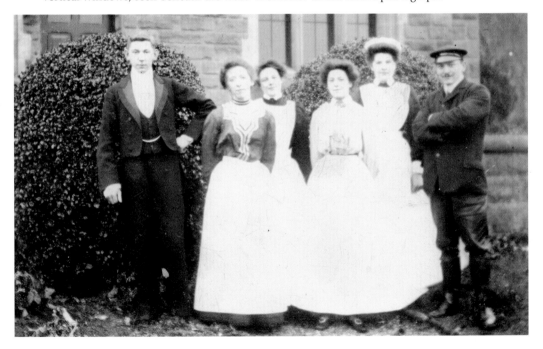

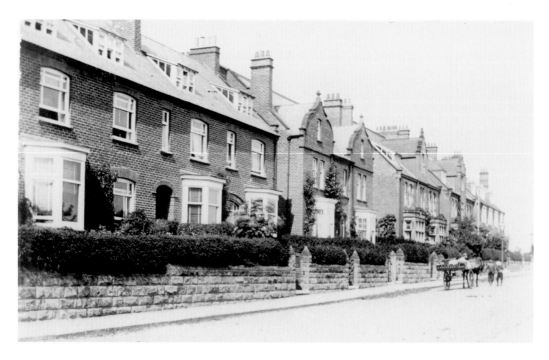

Mount Pleasant South

The Mount Pleasant estate was built without thought for where motorcars might park in the future. This is clearly seen in the old photograph, where each house has a pedestrian entrance only, in the front wall. Now many of the owners have sacrificed their gardens, and the front walls, to provide off-street parking for themselves and their visitors. This, and the growth of trees, has changed the appearance and integrity of this fine street of late Victorian houses.

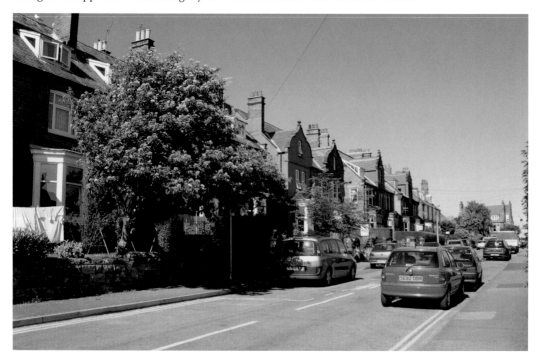

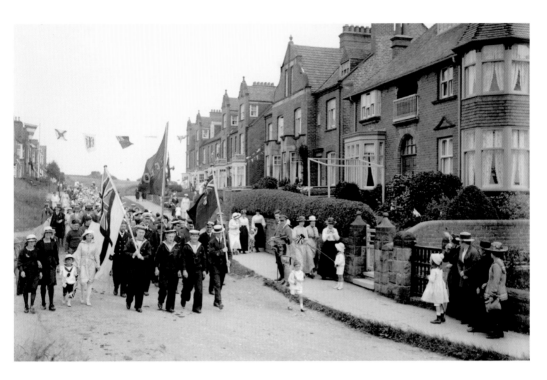

Mount Pleasant North

The Peace Celebration Day procession (see page 70) on Mount Pleasant North. In the advertising for the Mount Pleasant estate in 1894, it was stated that the estate 'affords splendid sites close to the sea for the erection of superior villa residences or high class boarding or lodging houses' and 'the estate is divided into 52 lots of convenient size, good supplies of gas and water are available'. An electricity supply was not connected to the village until 1932.

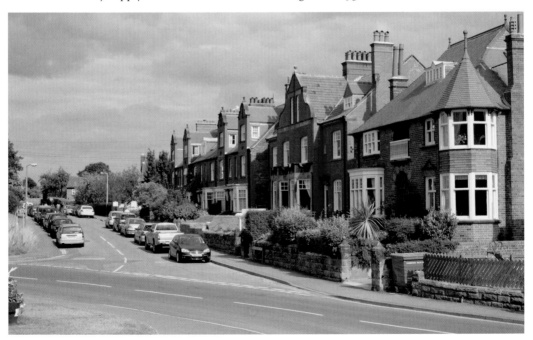

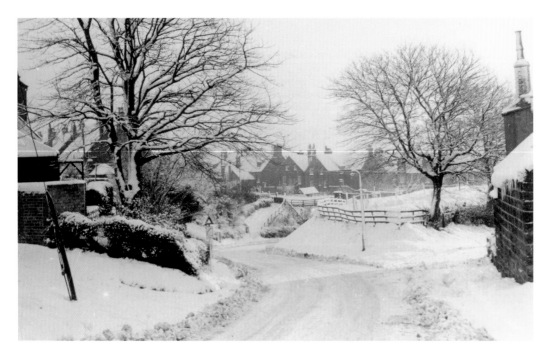

The Whitby Road into Robin Hood's Bay

On the left, behind the tree, are the houses of Elm Grove, and on the extreme right, the old stable yard used by the Turners' horses. The road leads down to the railway over-bridge (centre) at the north end of the railway station and beyond are the houses of Mount Pleasant North. The bridge was demolished after the railway tracks were lifted in 1967. The whole of the railway track between Scarborough and Whitby is now a very scenic walking and cycling trail.

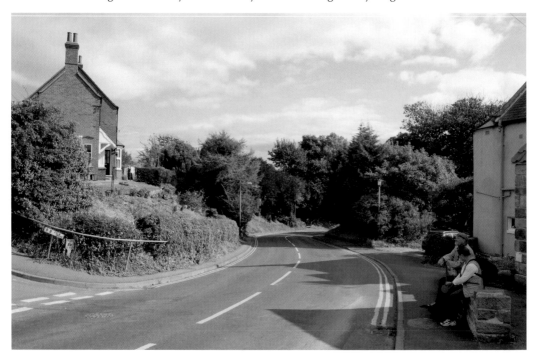

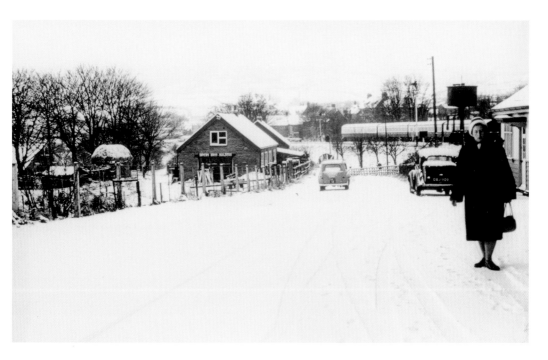

Outside the Railway Station

This view, taken from just outside the station waiting rooms, shows the road down to Thorpe Lane. The railway company closed the road once a year and charged a penny to use it unless you were going to the station or the post office — a lot of penny stamps were bought on that day! On the right is a row of static railway camping coaches that were very popular with holidaymakers. The old wooden post office and Refreshment Room building, on the right, still survives.

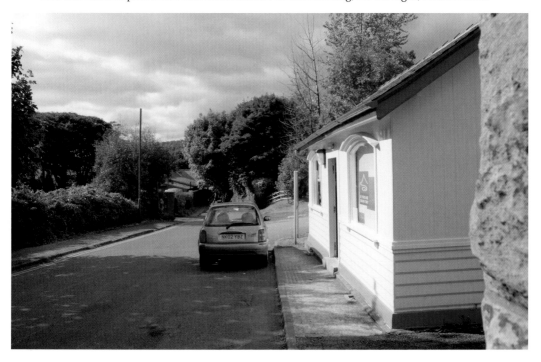

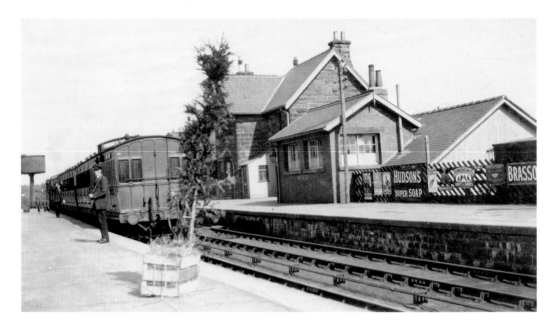

Robin Hood's Bay Station

Robin Hood's Bay station was the largest station on the line that opened on 16 July 1885. The low roof on the right is the post office and refreshment room of 1904. This adjoins the original signal box and behind that is the two-storey stationmaster's house. On the far left is the water tank that served the locomotives heading towards Whitby, and on the platform is a lonesome pine! All these buildings are now difficult to photograph from this viewpoint but tickets survive to recall happy memories.

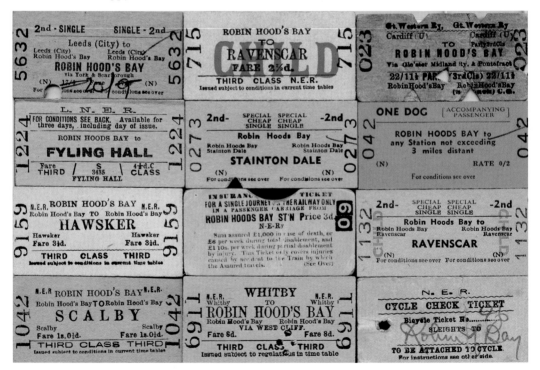

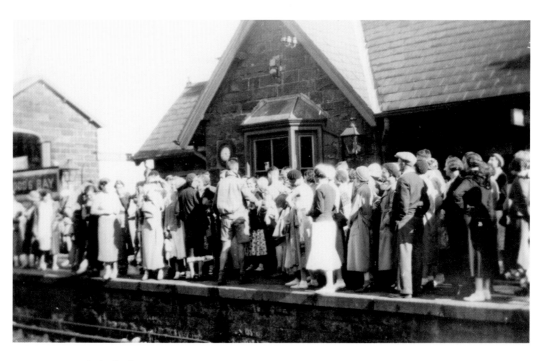

A Crowded Platform

In 1933, a group of walkers, from Cober Hill at Cloughton 10 miles away, wait for a train back to their base. The station waiting rooms are behind the crowd, and the building on the far left is the goods warehouse. In front of the warehouse, partly visible, is the old North Eastern Railway 'Robin Hood's Bay' enamel sign. The 'Hood's Bay' part of this was found in a field in the area a few years ago, but the whereabouts of the 'Robin' is not known!

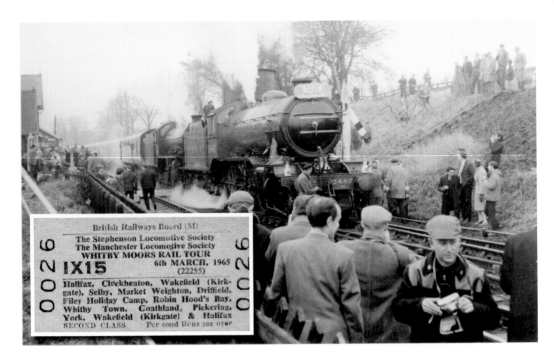

British Railways Board (M)
The Stephenson Locomotive Society
The Manchester Locomotive Society
WHITBY MOORS RAIL TOUR
1X15 6th MARCH, 1965
(22255)
Halifax, Cleckheaton, Wakefield (Kirkgate), Selby, Market Weighton, Driffield, Filey Holiday Camp, Robin Hood's Bay, Whitby Town, Goathland, Pickering, York, Wakefield (Kirkgate) & Halifax
SECOND CLASS For conditions see over
0026 0026

The End of an Era — The Whitby Moors Rail Tour

The last day of passenger traffic at Robin Hood's Bay station was 6 March 1965, when, apart from the normal Diesel Multiple Unit service trains, this splendid double-headed steam locomotive-hauled excursion stopped at the station. This site, viewed from the north, is virtually unrecognisable as a former railway station, as the whole of the north end is now a car and coach park. The new village hall, incorporating a very much modified goods warehouse (on the left) stretches right across the site of the original tracks.

Inset: A ticket for the Whitby Moors Rail Tour.

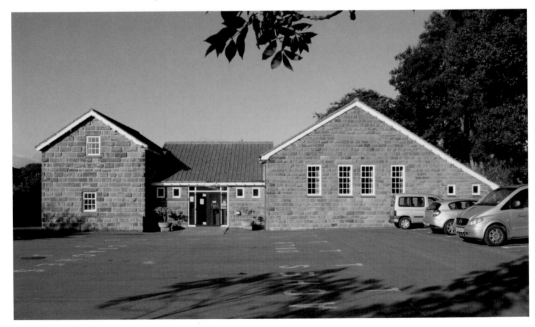

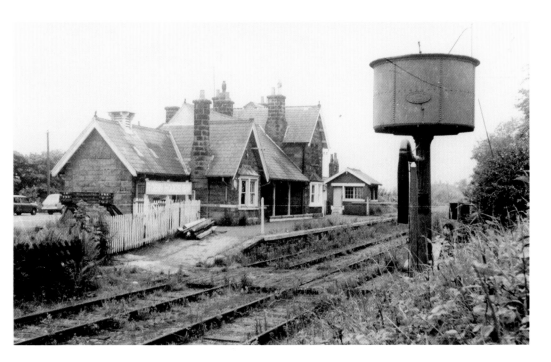

A Station in Limbo

The weeds creep in, the station is silent and the water tank stands sentinel over a scene of dereliction in 1966 as the site awaits its fate. The track was lifted the following year when the scrap merchants moved in. Fortunately, all the buildings survive, but the splendid water tank went for scrap. The station waiting rooms and loft have been sympathetically restored and now provide attractive holiday accommodation. The village hall now occupies the site from which the old photograph was taken.

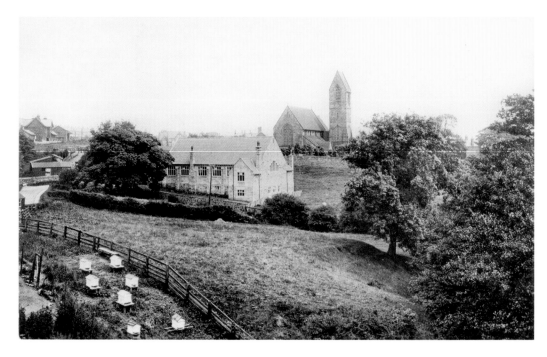

The Old Parish Hall and St Stephen's Church

The old parish hall (centre) was completed in 1912. Although over half a mile from the sea and the hazards of cliff erosion, only seventy years later it was found to be suffering from subsidence. A new village hall was built on the station site, incorporating the old goods warehouse that can be seen next to the station buildings on the extreme left. The recent view was taken from the edge of the field, opposite St Stephen's church, that was the site of the parish hall.

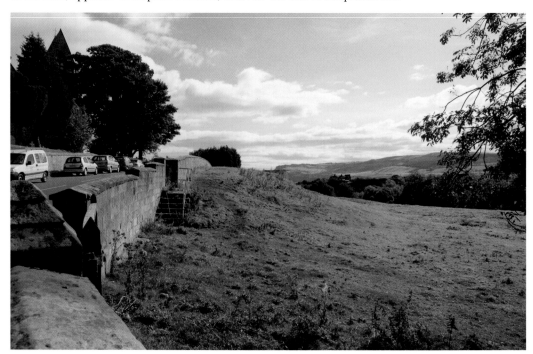

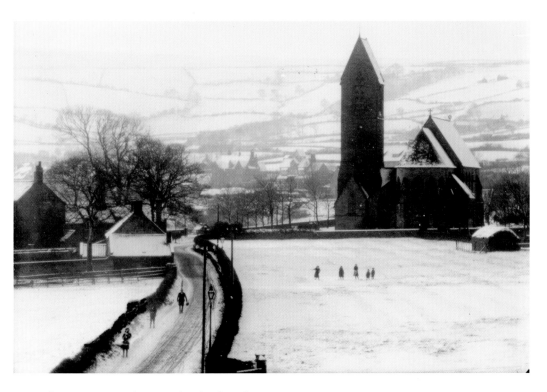

Thorpe Lane and St Stephen's Church

A wintry view taken in January 1914. This provides a great contrast with the present-day scene, where houses, bungalows and council houses have sprung up on both sides of Thorpe Lane. St Stephen's church was consecrated in 1870 and replaces the old St Stephen's church, above Fylingthorpe. The cost of the new church, about £6,000, was paid for by Mr Robert Barry, a local landowner. The tower is 120 feet high and forms a distinctive landmark that can be seen for miles around.

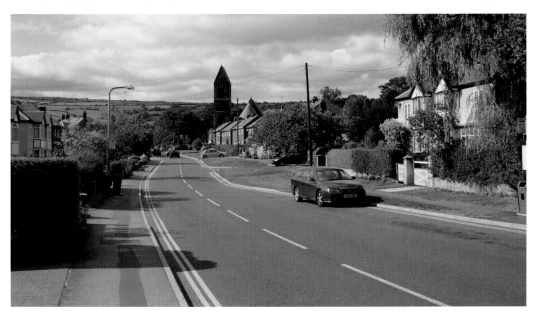

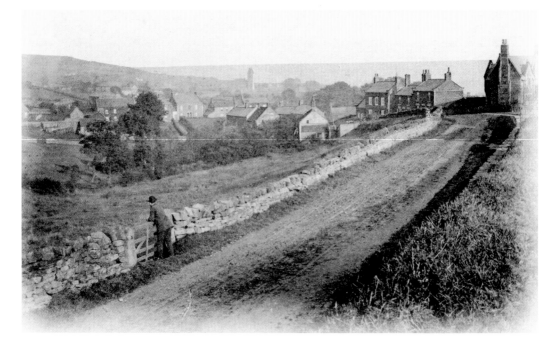

Fylingthorpe from the Sledgates Road

Fylingthorpe or Thorpe, as it is usually referred to, is a small village half a mile from Robin Hood's Bay station. It nestles in a shallow ravine at the bottom of Sledgates, the road leading up onto the moors that join the A171 between Scarborough and Whitby. On the right is the old National School building, where the older boys from Robin Hood's Bay were taught. Houses have been built on both sides of the road since the old photograph was taken.

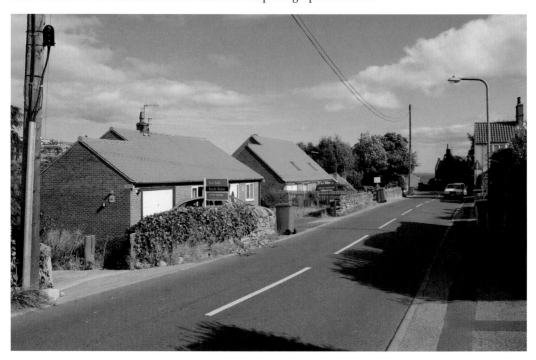

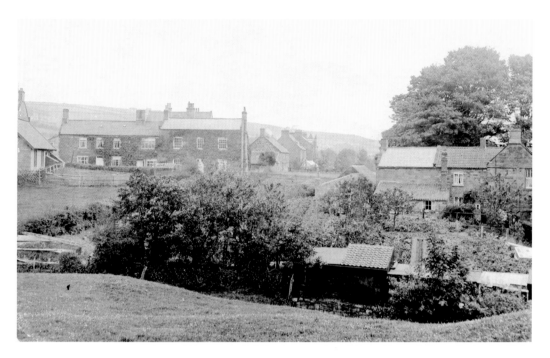

The Heart of Fylingthorpe

This old photograph, looking across towards Middlewood Lane, was taken from behind the row of houses below the school in the previous photograph in the area called Thorpe Green. On the extreme left is the Wesleyan chapel, and on the grassy area next to it, near the road, there is now a quoits pitch and a children's playground. At the time the recent photograph was taken, the public toilets here had just been completely demolished and will not be rebuilt.

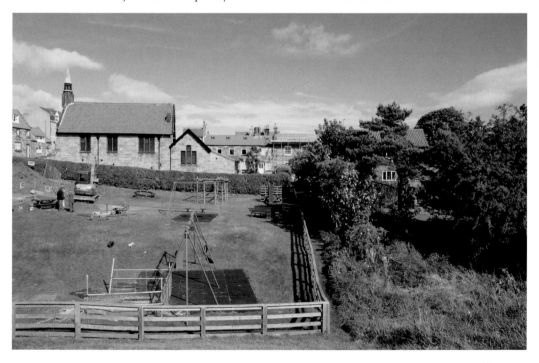

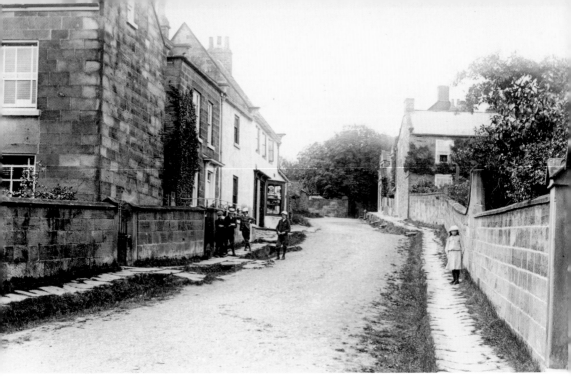

Thorpe Green Lane, Fylingthorpe

The bay window of Rosslyn Stores, now closed, can be seen on the left, towards the top of Thorpe Green Lane, in about 1910. The Fylingthorpe National School is at the very top of the lane, on the right. There appears to be a marked segregation of the sexes with four boys on one side of the lane and a girl on the opposite side, all posing patiently for the photographer! The recent view illustrates the problems of parking in a small seaside village, especially in August.

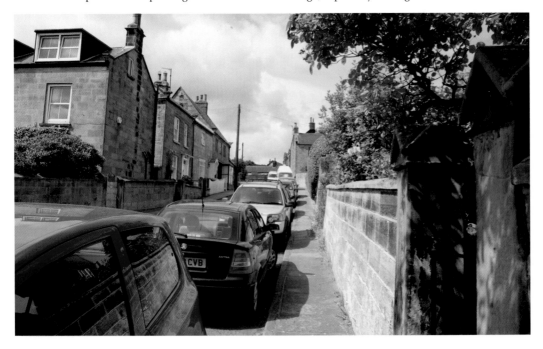

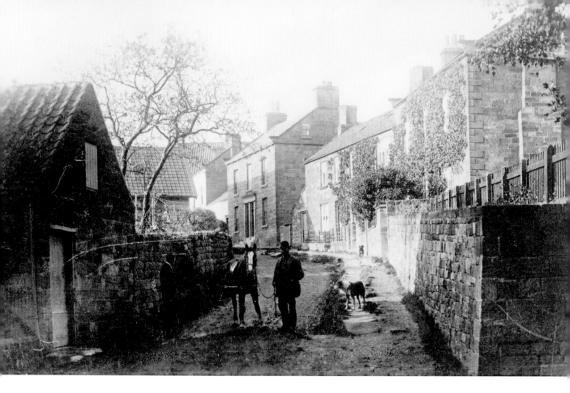

Middlewood Lane, Fylingthorpe

The old photograph was taken from near the entrance to Thorpe Hall, looking up Middlewood Lane towards the crossroads. In 1890, there were two public houses in Fylingthorpe: the old Fylingdales Inn, the whitewashed building at the top of the street, and the Royal Oak, long since closed, that was opposite the entrance to Thorpe Hall. The principal landowner here was Mr William Farside of Thorpe Hall.

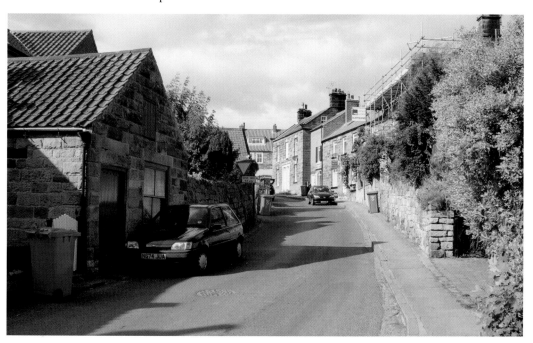

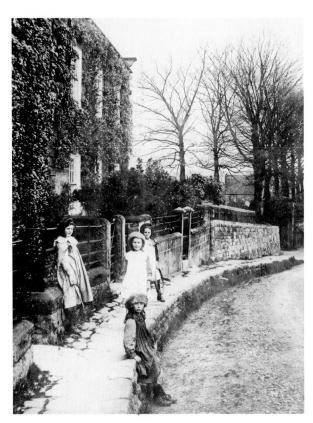

Middlewood Lane, Fylingthorpe
Local girls pose for the photographer on Middlewood Lane. Two of the girls are holding iron hoops — 'booling' hoops was a popular pastime. Local blacksmiths were usually able to provide a small iron cartwheel rim or a hoop off a barrel. The roof of Thorpe Hall can just be seen through the trees; it was rebuilt in 1640, and had a stone slab over a chamber in the grounds where a tub of gin or barrel of brandy could be left by smugglers.

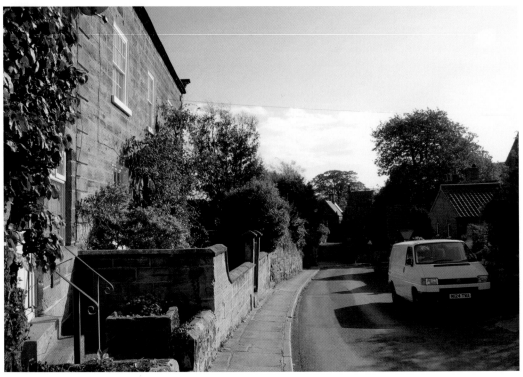

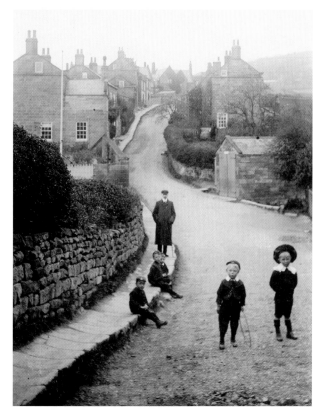

Thorpe Bank, Fylingthorpe
The main street through Fylingthorpe leading up to Sledgates, where small boys can no longer play in the middle of the road with impunity! Note the old stone-slabbed footpath on the left — many of the old stone 'Trods' have survived in this area, and once, they provided the only means of travelling between the villages and over the moors to Pickering. The ancient game of quoits is very popular in the Whitby area and the Quoits pitch at Fylingthorpe is behind the wall on the left.

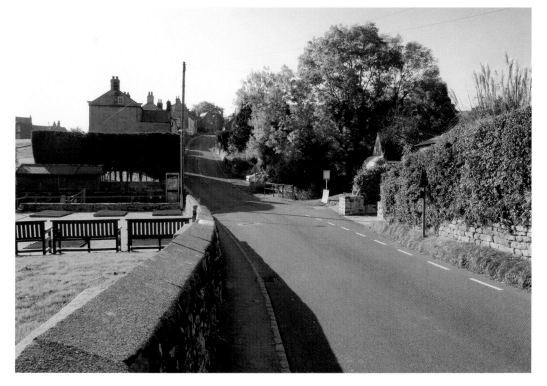

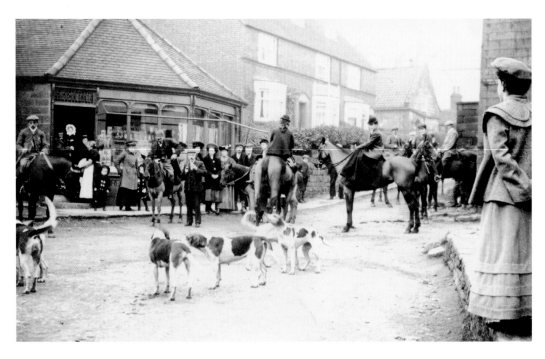

The Hunt at the Crossroads, Fylingthorpe

The old crossroads at Thorpe have seen the greatest change in this village as the Fylingdales Inn, just off the picture on the right, was demolished to make the road wider for motorised traffic. On the left, W. A. Smith's Fylingdales Stores sold a wide variety of merchandise but business came to a temporary halt when the Staintondale Hunt paused to regroup at the crossroads. The shop is now Thorpe Stores, and a number of customers appear to have arrived by bicycle!

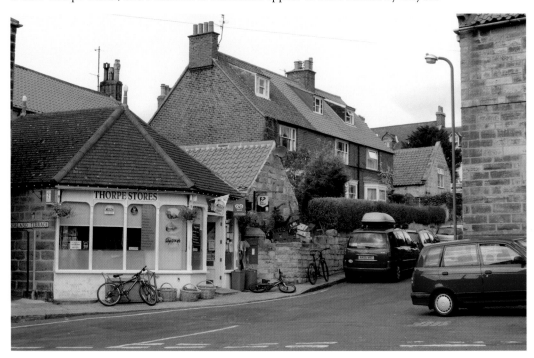

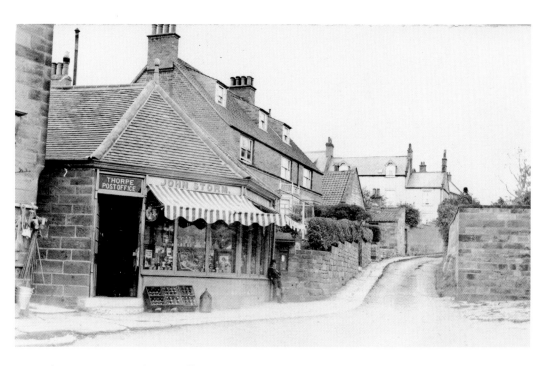

Thorpe Stores and Post Office

When W. A. Smith sold Fylingdales Stores, it was taken over by his manager, John Storm. Crates of beer seem to be a prominent sales item in front of the shop and faint lettering on the wall under the window next to the lounging boy reveal that 'Tobacco & Cigars' were also being promoted. This photograph was taken in about 1922 and shows Church Lane, widened in the recent photograph, which climbs up to the old St Stephen's church about a quarter of a mile away.

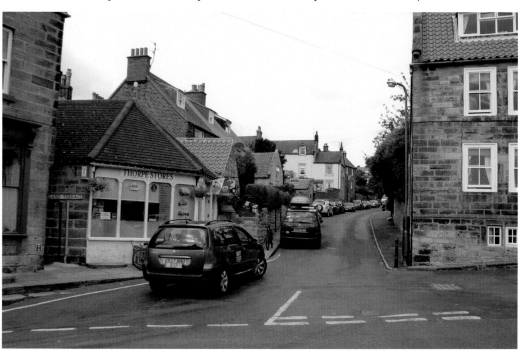

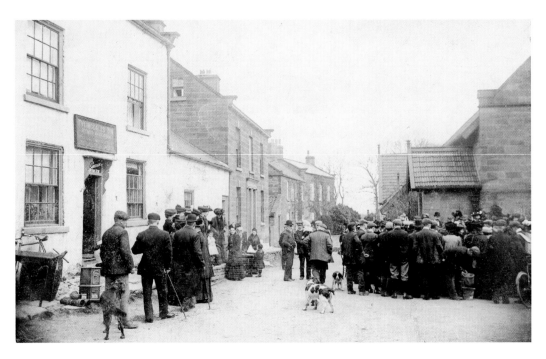

The Crossroads, Fylingthorpe

This intriguing photograph of the old Fylingdales Inn is a puzzle. Outside the inn are various household items, and it would appear, an auction is in progress. The inn was demolished in about 1960 in order to widen the road at the crossroads. In the recent photograph, the old inn has gone, but the line where the stable roof was attached can be traced on the end of the building on the left. The inn moved to a new location round the corner on Thorpe Lane.

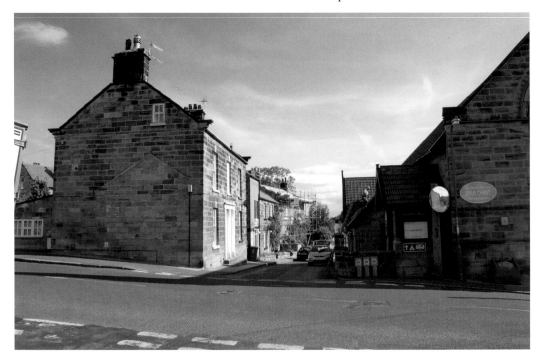

The Water-splash, Fylingthorpe
Further down Middlewood Lane, below the old Fylingdales Inn and past the entrance to Thorpe Hall, is this picturesque water-splash through Thorpe Beck. On the right, pedestrians can stay high and dry on a narrow stone bridge, whilst on the left, a workman repairs the road and ensures that the waterway is kept clear to prevent flooding in stormy weather. The only change here is the addition of handrails to prevent pedestrians from falling in the beck!

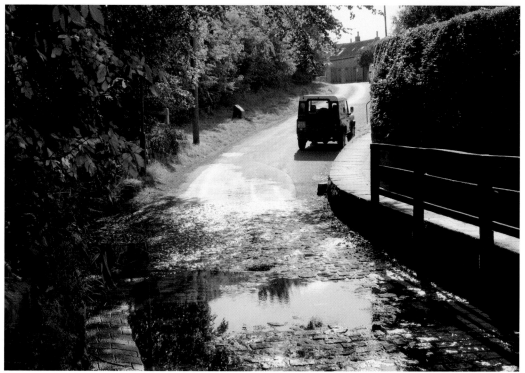

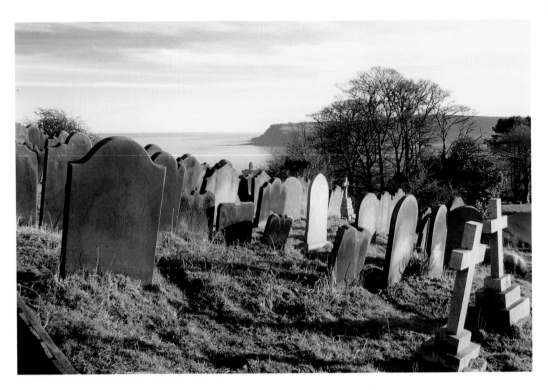

Safely Anchored
The gravestones in the old St Stephen's churchyard, perched high on the hill above Robin Hood's Bay and Fylingthorpe, appear to jostle for the best view over the bay towards Ravenscar. For everyone who visits here, there is beauty and magic under these northern skies, and what better place could there be to remain anchored for eternity?

Acknowledgements

I am grateful to the following for their help and advice in the compilation of this book: Alan Staniforth; Fred Rowntree; Kathy Roden; Margaret Pennock; Paddy, Patrick and Gulden Holdsworth; Rob Rymer; Ron and Diane Noble; Susan Webster; T. F. Harland; the late Beryl McNeil; the late Rebecca Storm Murrell; The Fylingdales Museum and Library Trust; and all those who kindly allowed me to include them in the photographs. I would also like to give special thanks to Val for her patience and help during the compilation of this book.